The Campus History Series

UNIVERSITY OF
SAN FRANCISCO

ON THE FRONT COVER: Pictured here is St. Ignatius Church and College on October 15, 1905, celebrating its 50th anniversary. (Courtesy of the University of San Francisco archives.)

COVER BACKGROUND: St. Ignatius Church and College in San Francisco is seen as it appeared in 1863. The building was located on the south side of an unpaved Market Street, between Fourth and Fifth Streets. (Courtesy of the University of San Francisco archives.)

The Campus History Series

UNIVERSITY OF SAN FRANCISCO

Alan Ziajka and Robert Elias

ARCADIA
PUBLISHING

Copyright © 2015 by Alan Ziajka and Robert Elias
ISBN 978-1-4671-3307-4

Published by Arcadia Publishing
Charleston, South Carolina

Printed in the United States of America

Library of Congress Control Number: 2014949302

For all general information, please contact Arcadia Publishing:
Telephone 843-853-2070
Fax 843-853-0044
E-mail sales@arcadiapublishing.com
For customer service and orders:
Toll-Free 1-888-313-2665

Visit us on the Internet at www.arcadiapublishing.com

Contents

Acknowledgments		6
Introduction		7
1.	Origins	9
2.	The Golden Age	17
3.	The Shirt Factory Era	29
4.	Surviving the Depression and War	57
5.	The Postwar Era through the 1960s	73
6.	The 1970s to the 2000s	101

ACKNOWLEDGMENTS

Many individuals made this book possible. We are indebted to Michael Kotlanger, SJ, USF archivist, who provided much of the primary material for the book, including photographs, newspapers, letters, and other documents. Candice Novak, assistant director for e-communications in the office of communications and marketing, also supplied a number of the photographs we used. We also greatly appreciate the skillful work of Eugene Vinluan-Pagal, production manager in the USF office of communications and marketing, who enhanced, organized, and oversaw the production of all the images used in this book. We are indebted to the work of Paola Cespedes de Ergueta, our research associate, and are grateful to two USF students, Emily McPartlon and Cindy Vo, who served over the past year as research assistants for the book.

Jennifer Turpin, provost, and Gerardo Marín, senior vice provost for academic affairs, both supported this project in many ways, including granting the time and resources necessary to complete the book.

In the final analysis, it has been the students, alumni, faculty, administrators, and staff at the University of San Francisco, stretching back 160 years, who made this book possible. The world is a better place because of the men and women who make up the extended USF community, and it is to these individuals that this book is dedicated. Unless otherwise noted, all images appear courtesy of the University of San Francisco archives.

—Alan Ziajka, PhD
Associate Vice Provost for Academic Affairs and University Historian
University of San Francisco

—Robert Elias, PhD
Professor of Politics
University of San Francisco

INTRODUCTION

The University of San Francisco began in 1855 as a one-room schoolhouse called St. Ignatius Academy. Its founding was interwoven with the establishment of the Jesuit order in California, European immigration to the western United States, and the population growth of California and San Francisco as a result of the California Gold Rush.

On October 15, 1855, the school opened its doors to its first class. Three students showed up, a number that gradually grew to 65 by 1858. In 1859, Anthony Maraschi, SJ, the founding president of St. Ignatius Academy, incorporated the institution under California state law, obtained a charter to issue college degrees, formed a board of trustees, and renamed the institution St. Ignatius College. Student enrollment, composed largely of first- and second-generation Irish and Italian immigrants, increased to 457 by 1862.

In 1880, further growth in the number of students prompted St. Ignatius Church and College to move to the corner of Hayes Street and Van Ness Avenue, the current site of the Louise M. Davies Symphony Hall. The college began at this new location with 650 students and rave reviews in the local press. The institution occupied a full city block and was described by the *San Francisco Post* as having "scientific laboratories and departments" as "thoroughly equipped as money can make them" and a library that contained "the cream of knowledge on all necessary subjects." The attached church was depicted as "magnificent" and could hold up to 4,000 people. In 1903, the college added a "splendid new gymnasium," portrayed by the *San Francisco Call* as the best in the city.

The history of St. Ignatius Church and College at this location came to an abrupt end on April 18, 1906. On the morning of that day, an earthquake, followed by several days of fire, brought the church and college, and most of San Francisco, to almost complete ruin. The city and the institution, however, quickly rebuilt from the devastation. In September 1906, St. Ignatius Church and School reopened in temporary quarters, known as the "shirt factory," on the southwest corner of Hayes and Shrader Streets, currently the site of one of the buildings of St. Mary's Medical Center. In 1927, St. Ignatius College moved into the new Liberal Arts Building, the present day Kalmanovitz Hall, near the corner of Fulton and Parker Streets. In 1930, at the request of several alumni groups, St. Ignatius College changed its name to the University of San Francisco.

For 160 years, the University of San Francisco has served the citizens of San Francisco and enriched the lives of thousands of people. The institution has graduated students who went on to become leaders in government, education, religion, business, journalism, sports, the sciences, and the legal and health-related professions. Among its alumni, the university counts three former San Francisco mayors, numerous current city officials, a former US senator, one

current and three former California Supreme Court justices, a former California lieutenant governor, two Pulitzer Prize winners, three Olympic medalists, several professional athletes, and a former president of Peru. USF has more than 100,000 alumni living in all 50 states, six US territories, and 129 countries.

Today, the University of San Francisco enrolls more than 10,700 students in its four schools and one college: the School of Law, founded in 1912; the College of Arts and Sciences, organized in 1925; the School of Management, which began in 1925 as the College of Commerce and Finance and was merged with the College of Professional Studies in 2009; the School of Education, which started as the Department of Education in 1947 and was upgraded to a school in 1972; and the School of Nursing and Health Professions, which began as the Department of Nursing in 1948 and became a school in 1954. USF is one of the most ethnically diverse universities in the nation. Among the entire fall 2014 student population, 47 percent were Asian, African American, Latino, Native Hawaiian/Pacific Islander, or Native American, and 16 percent were international. In 1964, USF became completely coeducational, though women had been enrolled in the evening programs in law and business since 1927, in education since 1947, and in nursing since 1948. In the fall of 2014, sixty-three percent of the overall student population was female.

Central to the mission of the University of San Francisco is the preparation of men and women to shape a multicultural world with generosity, compassion, and justice. The institution's vision, mission, and values statement, approved by the board of trustees on September 11, 2001, after a year of formulation and campus-wide participation, captures the essence of this commitment in its opening paragraph: "The University of San Francisco will be internationally recognized as a premier Jesuit Catholic, urban University with a global perspective that educates leaders who will fashion a more humane and just world." This mission permeates all aspects of the institution, including student learning and faculty development, curriculum design, program and degree offerings, alumni relations, publications, and a host of other institutional features.

In 2005, the University of San Francisco celebrated the 150th anniversary of its founding. The main USF campus currently occupies 55 acres near Golden Gate Park in San Francisco. Additionally, the university offers classes at four Northern California branch campuses (Sacramento, San Jose, Santa Rosa, and Pleasanton), at a Southern California branch campus, and at locations in downtown San Francisco, including the Folger Building at 101 Howard Street and the Presidio. The university also offers students a multitude of international experiences and study-abroad programs that enrich the learning community. The institution has grown dramatically since its modest beginning. It continues, however, to fulfill a mission that stretches back in time to the founding of the Society of Jesus in 1540 by St. Ignatius of Loyola, took root in San Francisco in 1855, and flourishes today in a premier Jesuit Catholic university.

One

ORIGINS

On January 24, 1848, James Marshall reached into a stream at Sutter's sawmill in the Coloma Valley, about 40 miles east of Sacramento, and pulled out a few shiny metal flakes. The excitement created by this discovery launched one of the greatest voluntary migrations in human history: the California Gold Rush. San Francisco, the port of entry to the goldfields of Northern California, saw its population swell from 459 people in 1847 to 34,776 by 1852. Hundreds of thousands more poured through the city on their way to the goldfields, coming from throughout the United States, Europe, Asia, Latin America, and Australia. The gold seekers reflected a multitude of cultural, religious, and ethnic backgrounds and represented every stratum of society. They were farmers, merchants, shopkeepers, Army and Navy deserters, soldiers of fortune, plantation owners, slaves, the rich, and the poor. Groups of convicts in Australian penal colonies were set free to go to California under the stipulation that they were never to return. The miners came by sailing ship and steamer through San Francisco Bay or overland by horse, mule, ox, covered wagons, and on foot. Thousands died during the journey, and many more succumbed to the disease and violence that characterized life in the goldfields. Of the hundreds of thousands who survived, some made fortunes, but most did not. In pursuing their dreams, however, they changed their lives forever and profoundly altered California and San Francisco.

The California Gold Rush transformed the Jesuit presence on the West Coast, which from 1844 to 1848 was centered in Oregon Territory. When gold was discovered in California, many Oregonians, including the Catholics who were congregants of the Jesuit mission in that area, left for the goldfields and the rapidly emerging mining communities of Northern California. In December 1849, two Italian Jesuit priests, Fr. Michael Accolti, superior of the Jesuit residence at Willamette, Oregon, and his associate Fr. John Nobili made a five-day voyage from Astoria, Oregon, to San Francisco. The City by the Bay was experiencing rapid growth and civic chaos. Murder, prostitution, thievery, and gambling were commonplace. Fortunes were made and lost in a day through various kinds of speculation. Upon arriving in the city, Father Accolti wrote the following: "Whether it should be called a madhouse or Babylon I am at a loss to determine; so great in those days was the disorder, the brawling, the open immorality, the

reign of crime which brazen-faced triumphed on a soil not yet brought under the sway of human laws." Another priest, Fr. Antoine Langlois, wrote in 1849, however, "in spite of the temptations of bar-rooms and saloons on every hand for the multitudes that frequented them . . . it was possible for a person to save his soul in San Francisco." Jesuits also believed that there was a place for education in this unruly town, and led by Anthony Maraschi, SJ, they started the first institution of higher education in the city of San Francisco.

St. Ignatius Academy was officially founded in 1855, though it was renamed St. Ignatius College in 1859 when the State of California issued it a charter to confer college degrees. In 1930, on the occasion of its diamond jubilee, the name was changed for the last time to the University of San Francisco. In the city named for St. Francis of Assisi, there continues a vision and a mission that stretches back to the first years of the Jesuit order in the 16th century and that finds expression at today's University of San Francisco.

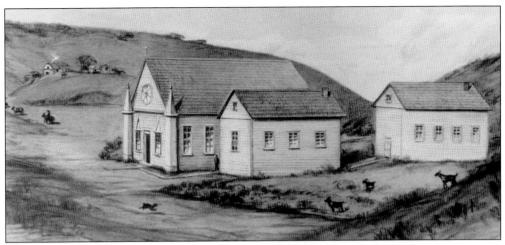

The University of San Francisco began its existence humbly as a one-room schoolhouse called St. Ignatius Academy. The institution's founding president, Anthony Maraschi, SJ, was a Jesuit from northern Italy who was teaching at Loyola College in Baltimore, Maryland, when the order reached him in 1854 to depart for California. When Father Maraschi arrived in San Francisco, he applied for and received permission from Archbishop Joseph Alemany to build a Jesuit church and school. When Father Maraschi asked the archbishop to designate a spot, His Grace pointed to a stretch of sand dunes west of the then-central part of San Francisco and, with a sweep of his hand toward the unoccupied land, said "any place over there." Father Maraschi chose a few sand dunes on the south side of Market Street, between Fourth and Fifth Streets, and proclaimed "Here, in time, will be the heart of a great city."

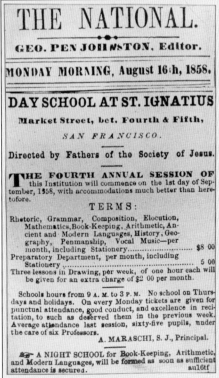

St. Ignatius Academy ran a series of advertisements in the local press to describe its curriculum, accommodations, tuition, and school hours. On October 15, 1855, the school opened its doors to its first class, which numbered three students. To greet those students, there were three instructors: Fr. Joseph Bixio, an Italian Jesuit; John Haley, a lay teacher from Ireland; and Fr. Anthony Maraschi.

Vision, faith, and determination are perhaps three of the most important characteristics needed by an individual seeking to start an enterprise and sustain it during its fledgling years. Anthony Maraschi, SJ, the founding president of St. Ignatius Academy, later to become the University of San Francisco, possessed these characteristics in great abundance. In August 1859, Father Maraschi received some well deserved and favorable press in the San Francisco newspaper *Alta California*: "The Reverend Anthony Maraschi, President of St. Ignatius College, is eminently qualified for the position, being a finished scholar and a man of high moral character. He has labored incessantly to advance the interests of those placed under his charge and the examination of several classes exhibited the complete success which has attended his efforts."

The outlook was not promising for the Jesuits on that fall day in 1855. On October 15, they began their experiment in education in San Francisco: St. Ignatius Academy. Three students showed up for class, including Richard McCabe (pictured), who later became a "well-known professional man of San Francisco," according to a report issued by the Jesuits of St. Ignatius Church and College in 1878, and two others whose names are unknown. Despite that disappointing start to what eventually became the University of San Francisco, enrollment gradually grew to 23 students by the end of the first academic year and to 65 students by 1858, the year before the institution became St. Ignatius College.

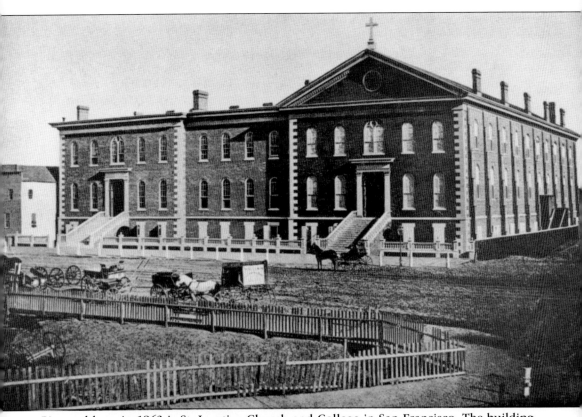

Pictured here in 1863 is St. Ignatius Church and College in San Francisco. The building, completed on Christmas Day, 1862, was located on the south side of an unpaved Market Street, between Fourth and Fifth Streets. The three-story brick structure that contained St. Ignatius Church and College featured large classrooms, scientific labs, and a Jesuit residence. It also included a large assembly hall, which was designed to be a temporary church. The entire building cost approximately $120,000 and attracted the attention of the local press. The *San Francisco Monitor*, for example, noted that the building's height "from where the brick work commences to the top of the cross in the center is 75-feet," and "the first floor, or basement, a portion of which is now used for public worship, is said to be the most spacious room in the city."

James Bouchard, SJ, a gifted public speaker, helped fill the new St. Ignatius Church in San Francisco with large audiences. From 1861 to 1889, he also traveled throughout the West giving sermons and public lectures, organizing support groups of Catholic laypersons (sodalities), and recruiting students for St. Ignatius College. His father was a Delaware Indian, and Father Bouchard, born in 1832, became the first Native American to be ordained a Catholic priest in the United States.

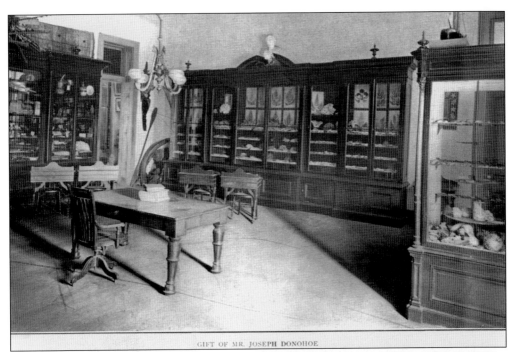

GIFT OF MR. JOSEPH DONOHOE

The first museum of natural history at St. Ignatius College, a collection of minerals and Native American artifacts, was given to the school by Joseph Donohoe in 1875. During the 1870s, the school also developed highly acclaimed scientific laboratories, called cabinets in that era, complete with the latest equipment. According to the *San Francisco Monitor*, they included scientific "apparatus second to none in the United States." St. Ignatius College also had a priceless ornithological collection and "magnificent" photographic equipment.

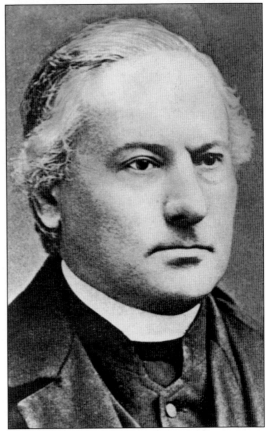

Joseph Bayma, SJ, world-renowned mathematician and scientist, taught at St. Ignatius College during the 1860s and 1870s, published some of the most important science and mathematics books of the era, and served at the institution's fifth president, from 1869 to 1873. His book *Elements of Molecular Mechanics* was the definitive text of its era on the subject. He also published a three-volume work on rational philosophy and a series of textbooks on college mathematics.

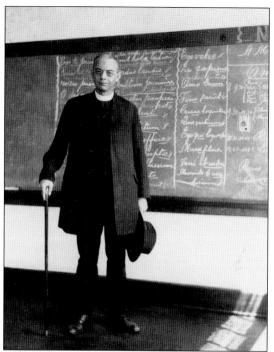

Joseph Neri, SJ, became chairman of the natural science department at St. Ignatius College in 1870. Over the next decade, he taught physics and chemistry, published scholarly papers, gave numerous public science lectures, and was the first person to demonstrate electric light to the citizens of San Francisco.

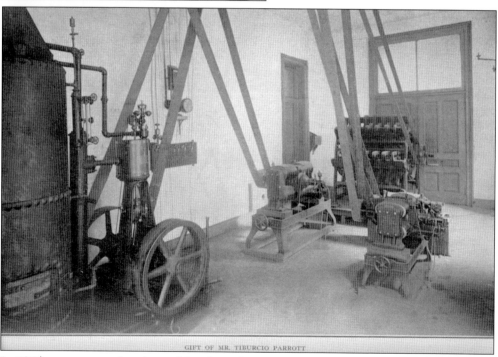

In 1874, a magneto-electric machine from Paris, France, given to St. Ignatius College by Tiburcio Parrott, was used by Joseph Neri, SJ, professor of natural philosophy at the college, to demonstrate the first electric lights in San Francisco. On July 4, 1876, to commemorate the centennial of the nation's independence, Father Neri attached the device to three searchlights mounted on top of St. Ignatius Church and illuminated all of Market Street.

Two

THE GOLDEN AGE

The second location in San Francisco for St. Ignatius Church and College was on the corner of Van Ness Avenue and Hayes Street, the current site of the Louise M. Davies Symphony Hall. The building occupied a full city block and was dedicated on February 1, 1880. This was actually the third St. Ignatius Church and College in downtown San Francisco. The first small church and school on Market Street, built in 1855, soon proved too small, and in 1862, a three-story building was erected on the same location, adjacent to the original buildings, to accommodate an increase in enrollment in the school and burgeoning membership in the church. Further growth in enrollment and membership and rising property taxes on Market Street prompted the Jesuits to acquire the Van Ness site. The new church and college built by the Jesuits later came to be known as "Old St. Ignatius" by the alumni of the early 20th century, and the period from 1880 to 1906 was often referred to as the institution's golden age. In 1880, the college opened its doors to 650 students and great reviews in the local press, where it was lauded for its outstanding scientific laboratories, classrooms, and libraries. The attached church was magnificent and could accommodate as many as 4,000 people. In 1903, the college added a new gymnasium, described as the best in the city. The church and college, a block from city hall, became a center for the educational and cultural life in the City by the Bay. The college's academic reputation spread throughout the state and nation; its drama programs and debating societies were known throughout the Bay Area, and many of its graduates became leaders in law, government, business, and religion. In October 1905, St. Ignatius College celebrated its Golden Jubilee, marking 50 years of educational excellence and service to the community.

The history of St. Ignatius Church and College on Van Ness Avenue came to an abrupt end on April 18, 1906. In the earthquake that struck early that morning and the days of fire that followed, the church and college, along with most of San Francisco, were reduced to almost complete ruin. Initially, the damage to both the college and church from the earthquake itself, though considerable, seemed reparable: walls cracked, plaster fell everywhere, the roof partially collapsed, and marble statues were thrown to the ground and broken. By far the worst came later that day, however, when fires broke out all over the city. They were

almost impossible to contain, because the earthquake had broken the city's main water pipes and cut off the water supply. The Hayes Valley fire, which destroyed St. Ignatius Church and College, was also called the "Ham and Eggs Fire," because it was started by a woman preparing breakfast in her nearby home after the earthquake. When she lit a fire in a stove connected to an earthquake-damaged chimney, the fire escaped from the chimney and quickly spread to neighboring buildings and the towers of St. Ignatius Church a block away. Without water, the Jesuit community and the firefighters had to watch helplessly as the institution was gutted by a raging inferno.

Although it is estimated that the San Francisco earthquake and fire of 1906 took more than 3,000 lives (the official count was 674), none of the 44 Jesuits at St. Ignatius Church and College, nor any of the school's students, were killed, though some were injured. The institution was, however, completely destroyed. What had taken half a century to develop lay in ashes, and the future was uncertain.

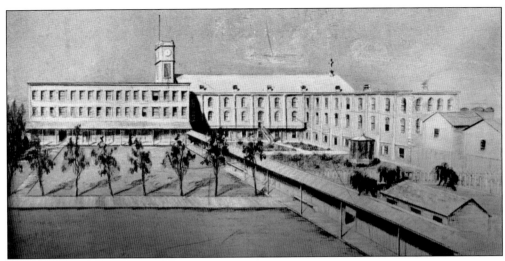

St. Ignatius Church and College is pictured here in the early 1870s, an institution already well known for academic excellence and service to the community. This tradition of using education to promote the common good stretches back to the first years of the Jesuit order in the 16th century and flourishes at today's University of San Francisco.

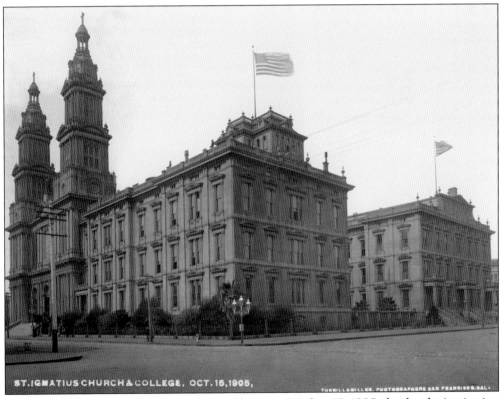

St. Ignatius Church and College is pictured here on October 15, 1905, the day the institution celebrated the 50th anniversary of its founding in San Francisco.

Jeremiah Sullivan, class of 1870, was the founding president of the college's alumni association, a superior court judge, and an associate justice of the California Supreme Court. (Courtesy of the Museum of the City of San Francisco.)

St. Ignatius College students had access to state-of-the-art scientific equipment during the institution's golden age, as evidenced by this chemistry lab in 1890.

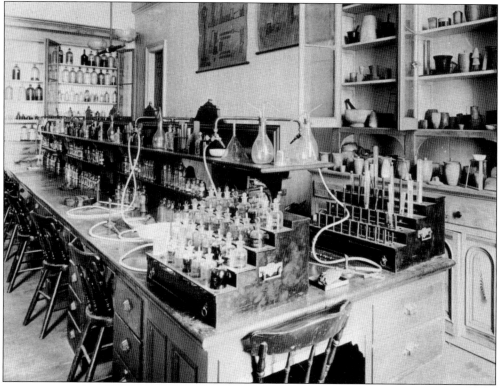

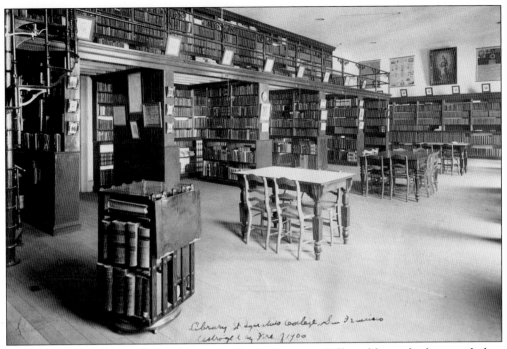

By 1900, at the height of its golden age, the St. Ignatius College library had expanded to include more than 30,000 books and nearly 8,000 journals—making it one of the best college libraries in the western United States.

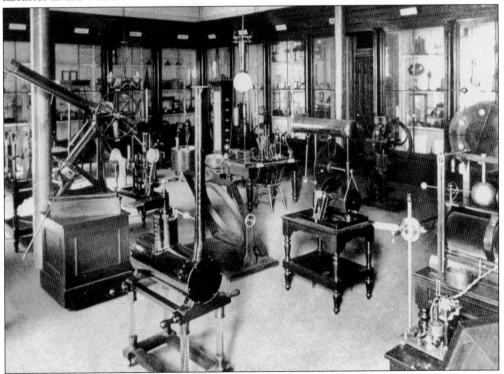

Pictured here is a physics lab or "cabinet" at St. Ignatius College in 1889.

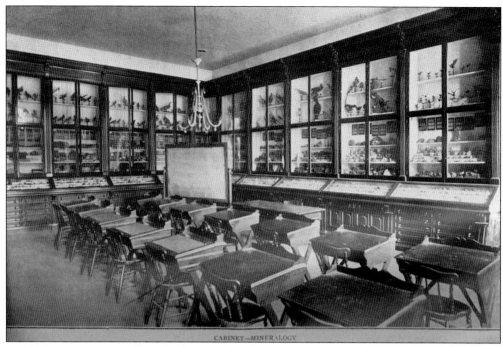

In 1890, St. Ignatius College had one of the finest mineralogy laboratories in the western United States.

Edward Allen, SJ, served as the 11th president of St. Ignatius College, from 1893 to 1896, and formed the college's first orchestra in 1898, two years after he left the presidency.

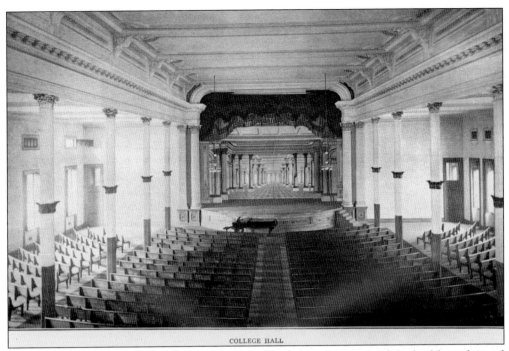

The St. Ignatius College auditorium served as the theater for many of the highly acclaimed performances by the institution's students during the golden age.

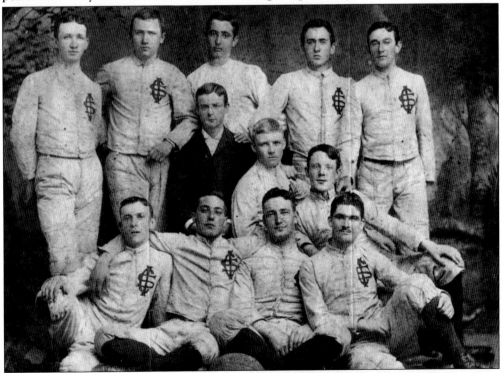

The rugby team of St. Ignatius College, composed of college and high school students, played its first game against Sacred Heart College on St. Patrick's Day, March 17, 1893.

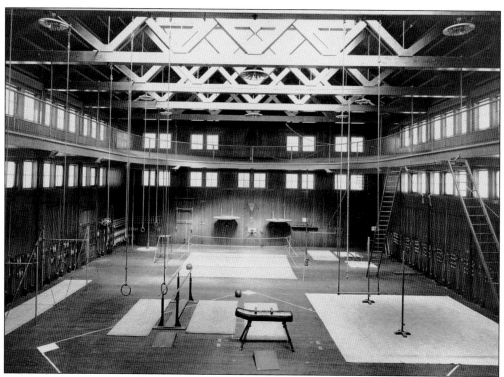
The St. Ignatius College Gymnasium, completed in 1903, sported an elevated running track suspended from the roof girders by iron rods and an indoor swimming pool.

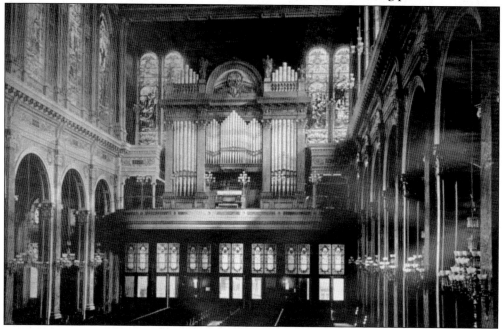
Pictured here is an interior view of St. Ignatius Church in 1897, highlighting one of the finest church organs in the nation, a gift from Bertha Welch, the most significant benefactor of the Jesuits of St. Ignatius Church and College from 1890 to 1922.

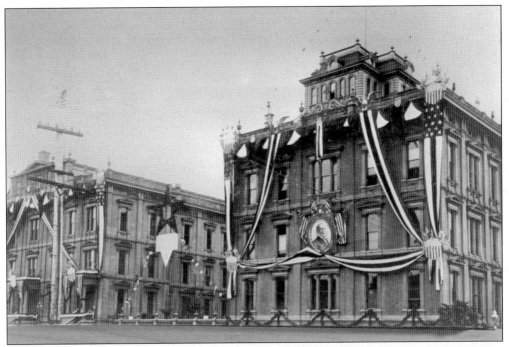

St. Ignatius Church and College is decorated for Pres. William McKinley's visit to San Francisco in May 1901. Four months later, St. Ignatius College students mourned his assassination.

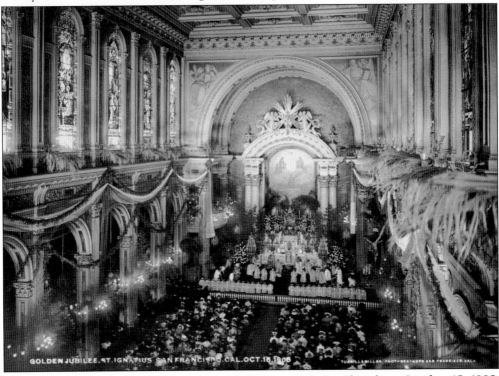

The Golden Jubilee Mass of Thanksgiving held in St. Ignatius Church on October 15, 1905, was a sight to behold. (Courtesy of the Society of California Pioneers.)

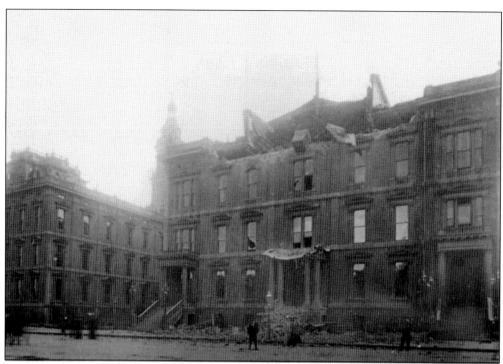

The damage to St. Ignatius Church and College was extensive but reparable after the earthquake struck Northern California on the morning of April 18, 1906. Then came the fire.

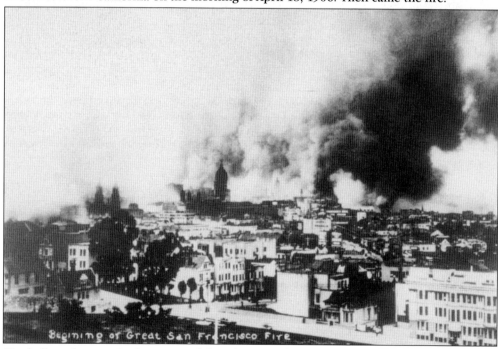

City hall can be seen in the center of this photograph depicting the fire that consumed San Francisco following the earthquake of April 18, 1906. To the right of city hall, a tower of St. Ignatius Church is visible through the smoke.

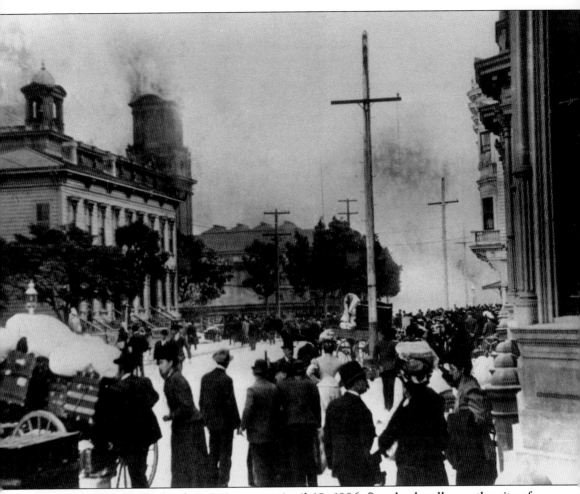

After the earthquake struck at 5:13 a.m. on April 18, 1906, fires broke all over the city of San Francisco, which the fire department could not effectively fight because the main water pipes throughout the city had been broken by the earthquake. One of those fires swept up Hayes Street and engulfed St. Ignatius Church and College, gutting the institution. (Courtesy of the California Province of the Society of Jesus Archives.)

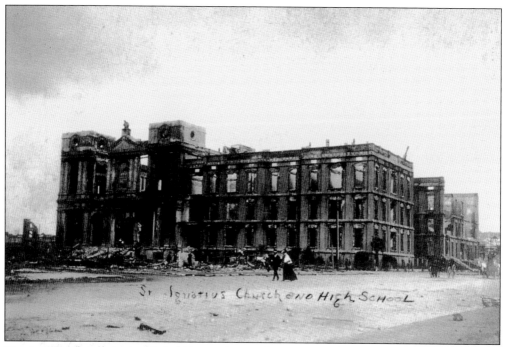

Pictured here are scenes of the devastation to St. Ignatius Church and College caused by the earthquake and fire of April 18, 1906. As John Frieden, SJ, the president of St. Ignatius College, put it, "What had taken half a century to build up and to equip, lay in ashes."

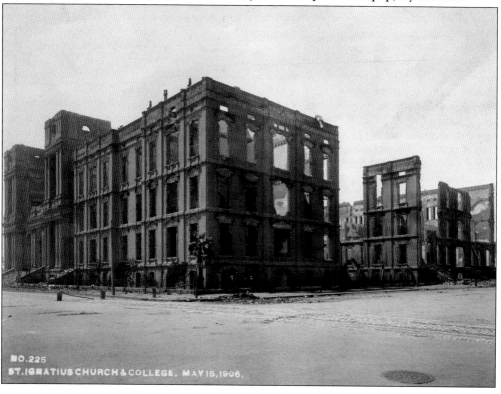

Three

THE SHIRT FACTORY ERA

On Sunday, July 1, 1906, less than three months after the San Francisco earthquake and fire destroyed St. Ignatius Church and College, ground was broken for a new location for the institution. The site, on the corner of Hayes and Shrader Streets, just two steep blocks south of today's campus, was to be only a temporary home. In fact, however, the building erected at this location served the Jesuits, their lay colleagues, and students for more than two decades. The rambling wooden building that comprised St. Ignatius Church and College came to be known as "the shirt factory" due to its resemblance to a number of hastily built structures south of Market Street, some of which actually housed shirt factories.

St. Ignatius College reopened its doors in the shirt factory on September 1, 1906, to 271 students ranging from sixth grade through college. Over the next 21 years, there were many key developments at the institution. In 1907, St. Ignatius College began athletic competition on a regular basis with other Bay Area high schools, colleges, and community organizations, using a mixture of high school and college students. The first sports were baseball, rugby, and basketball. In 1911, the *Ignatian* literary magazine was founded, and it is still published today. The School of Law began in September 1912 in the old Grant Building on Market and Seventh Streets, but it moved to the shirt factory in 1917. A College of Engineering was also started in 1912, and St. Ignatius College was renamed the University of St. Ignatius.

With America's entrance into World War I in 1917 and the subsequent draft, the university division declined to less than 100 students. The college participated in a military training program, and 10 of its students were killed in the war. There are 10 gold service stars on the current service flag of the University of San Francisco to commemorate these deaths.

By 1919, owing to a precipitous decline in enrollment, enormous cost overruns on the rebuilding of St. Ignatius Church, and a major recession in the nation and in the Bay Area, the institution's financial situation became dire. The debt rose to more than $1 million, and the church and school teetered on the brink of bankruptcy. The name of the school was changed back to St. Ignatius College in 1919, the College of Engineering was closed, and the leadership of the church and school, with support from alumni and the community, launched a successful fundraising effort to save the Jesuit institution.

By 1924, the debt had been brought under control, and enrollment had begun to steadily increase. Numerous changes were also made to the curriculum to reflect changing student and social needs. In 1924, a business program began as a four-year evening certificate option, and by 1925, the College of Commerce and Finance was established, the forerunner of today's School of Management. In that same year, the Departments of Arts, Sciences, and Philosophy officially became the College of Arts and Sciences to reflect various program changes, including an increase in the number of elective courses offered to students. In 1926, with a significant increase in student enrollment, work was begun on the new Liberal Arts Building, the present Kalmanovitz Hall. In 1927, this new building was dedicated, and St. Ignatius College moved to its present location. By then, the college's drama, debate, and athletic programs had achieved considerable prominence in the western United States.

St. Ignatius Church moved from the corner of Hayes and Shrader Streets to its current location in 1914, and the high school division moved from the shirt factory in 1929 to a building on the corner of Turk Street and Stanyan Street, the current site of the Koret Health and Recreation Center. The old shirt factory was eventually torn down, and the site is now the location of the Sister Mary Philippa Health Center, one of the buildings of St. Mary's Medical Center and the location of the health services clinic for current USF students.

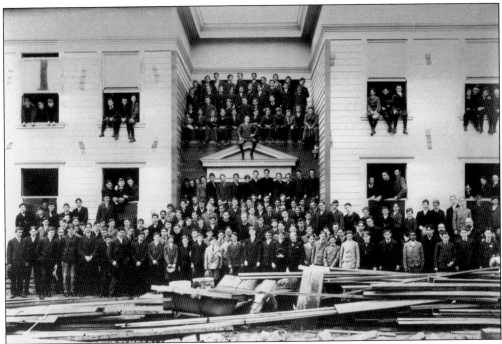

Pictured here is the first day of class, September 1, 1906, at St. Ignatius College, when it was housed in a temporary structure known as the shirt factory, a wooden structure that was hastily nailed together following the 1906 earthquake and fire.

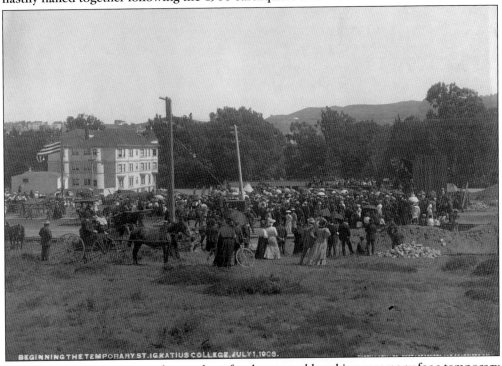

On July 1, 1906, a large crowd turned out for the ground-breaking ceremony for a temporary St. Ignatius College at the corner of Shrader and Hayes Streets.

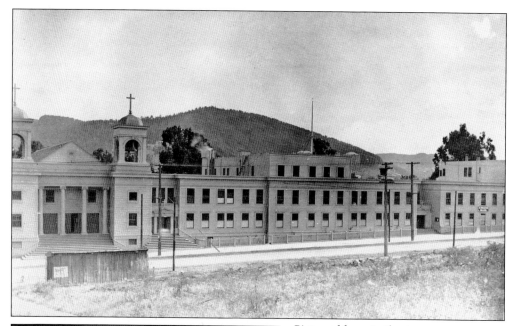

Pictured here is the temporary St. Ignatius Church and College as it looked in 1911. The site, on the corner of Hayes and Shrader Streets, is now occupied by a clinic and parking structure for St. Mary's Medical Center.

John Frieden, SJ, 12th president of St. Ignatius College, guided the institution through the difficult period of the San Francisco earthquake and fire of 1906.

Bertha Welch offered the Jesuits of St. Ignatius Church and College her mansion on Eddy Street as a temporary home after the destruction of their institution in the earthquake and fire of 1906. The Jesuits stayed there for five months while they built a temporary church and college near Golden Gate Park.

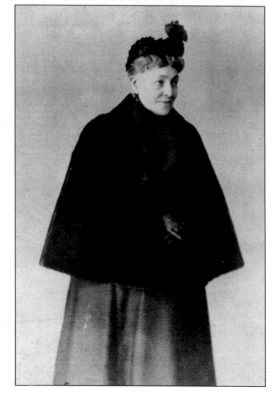

No benefactor was more important to the well-being of St. Ignatius Church and College in the late 19th and early 20th centuries than Bertha Welch. She supported the Jesuits during the bleakest hours following the earthquake and fire of 1906 and played a major role in the rebirth of the institution. (Courtesy of John Yarrington.)

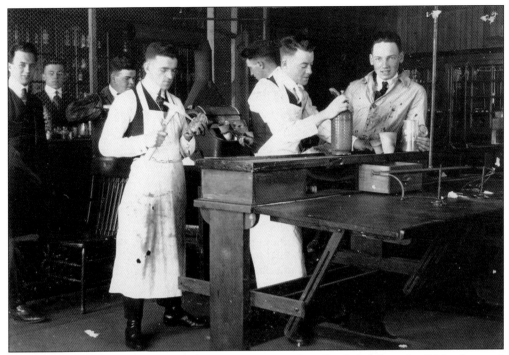
St. Ignatius College chemistry students are seen working in their lab at the "shirt factory," as the college was known from 1906 to 1927.

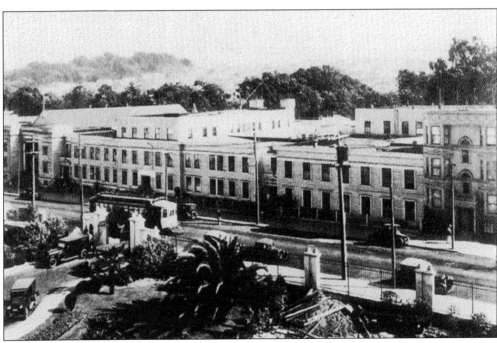
This 1925 photograph depicts one of the streetcars that traveled down Hayes Street bringing students to St. Ignatius College when it was located in the shirt factory from 1906 to 1927.

All of the premedical students at St. Ignatius College were required to complete a series of rigorous chemistry classes—just like USF's premedical students today. The chemistry lab pictured here dates from 1910, when the school was located in the shirt factory, a temporary building on Hayes Street between Shrader and Stanyan Streets, two blocks south of the current USF campus.

Pictured here are some members of the St. Ignatius College class of 1909. They originally attended the college when it was located in a magnificent building on the corner of Van Ness Avenue and Hayes Street that was destroyed by the earthquake and fire of 1906. Having survived that disaster, these students graduated from St. Ignatius College after it was rebuilt on the corner of Hayes and Shrader Streets, in what became known as the shirt factory.

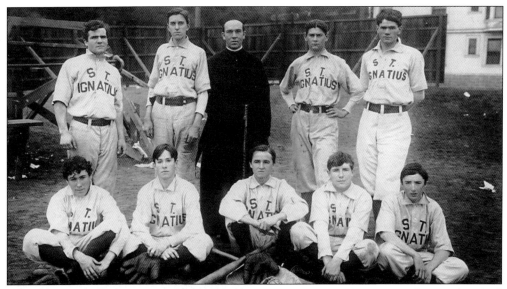

Pictured here in 1907 are members of the first St. Ignatius College intercollegiate baseball team, along with their coach, Joseph Sullivan, SJ. From left to right are (first row) Vincent Brown, Richard Hyland, Eddie O'Hara, Jerry Mahoney, and Charlie Knight; (second row) Jack Ryan, Ray Kearney, Father Sullivan, Tom Dorland, and Laurence "Kid" Reagan.

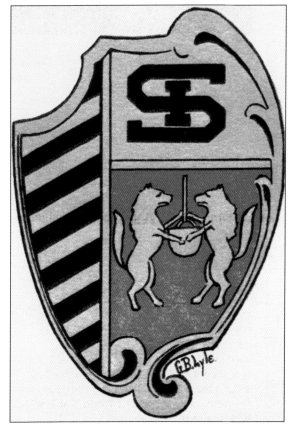

The cover of the June 1912 *Ignatian* displayed the St. Ignatius College seal. The design elements in the seal are traceable to the 10th century and the coats of arms of the Spanish noble families of Loyola and Oñaz. The Loyola family coat of arms depicted two wolves standing on either side of a kettle, symbolizing the generosity of the Loyola family in sharing food with others. The family of Oñaz was symbolized by seven red bars on a field of gold, standing for the bravery of seven members of the family who distinguished themselves in battle. At a meeting of American Jesuit Alumni Associations in 1889, it was proposed that a seal be developed that would identify the wearer as a student or alumnus of a Jesuit college. By 1900, several Jesuit colleges had created seals that adapted the coat of arms of the Oñaz y Loyola family. In 1909, George Blake Lyle, a student at St. Ignatius College, designed a variation of the seal, which first appeared on the cover of the 1911 *Ignatian*.

Michael O'Shaughnessy was the College of Engineering's founding dean. He also served as San Francisco's city engineer from 1912 to 1934. As the city's chief engineer, he developed the plans for streetcar lines to serve the Panama-Pacific International Exposition, extended the Municipal Railway lines into areas of the city that had no service, oversaw the development of the Muni streetcar system, and directed the development of new sewers, boulevards, tunnels, and a high-pressure fire system. For more than 20 years, he directed the controversial $100-million project that brought water from the Hetch Hetchy Valley in Yosemite National Park to San Francisco.

The cover of the December 1914 *Ignatian* noted the recent change in the school's name, from a college to a university, prompted in part by the addition of a law school and an engineering school in 1912. One of the magazine's editorials condemned the onset of World War I, which had begun in Europe in August 1914.

37

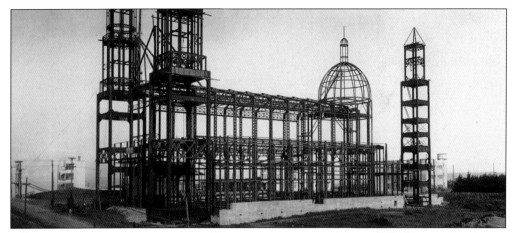
In 1911, work was begun on the steel superstructure, towers, and campanile of St. Ignatius Church. Engineers designed the church to withstand enormous stress, a fact ably demonstrated when a strong earthquake rocked the San Francisco Bay Area in October 1989, during which the church suffered virtually no damage.

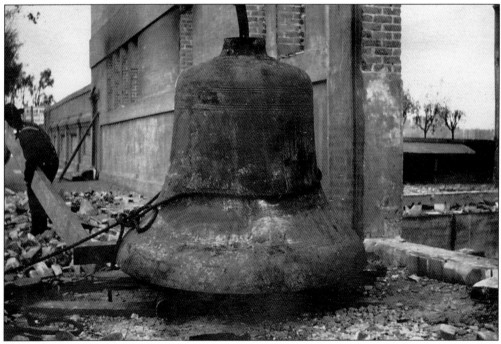
Antonio Maraschi, SJ, founding president of St. Ignatius Academy, purchased this bell for his new church and school on Market Street and had it hoisted to the church tower. In 1879, it was moved to the corner of Van Ness Avenue and Hayes Street, the new site for St. Ignatius Church and College. During the 1906 earthquake and fire, the bell crashed through several floors to the basement of the ruined St. Ignatius Church. It was recovered from the smoldering rubble a few weeks later unharmed and moved to the corner of Hayes and Shrader Streets, the temporary site of the church and college. In 1914, the bell was hoisted to the campanile of the present church, where it summoned San Franciscans to the first mass in the new St. Ignatius Church on August 2, 1914. It still rings there today. (Courtesy of the California Province of the Society of Jesus Archives.)

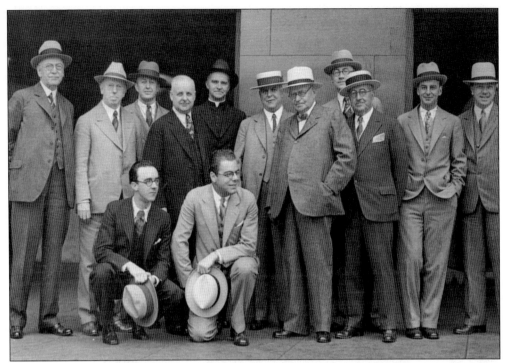

In the early 1930s, many of the founders of the University of San Francisco School of Law gathered for a group photograph. They include Eustace Cullinan Sr., standing fourth from the left; Matthew Sullivan, standing fifth from the right; and Thomas Hickey, standing third from the right. The priest standing in the middle is Edward Whelan, SJ, the president of St. Ignatius College and USF from 1925 to 1932. To the right of Father Whelan is James Rolph Jr., the mayor of San Francisco from 1912 to 1931 and a major supporter of the School of Law.

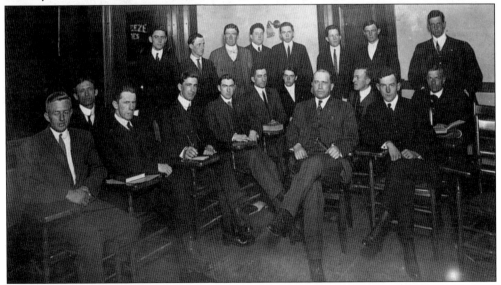

Pictured here in 1916 is Benjamin McKinley's constitutional law class, held on the fifth floor of the old Grant Building on the corner of Seventh and Market Streets. In addition to teaching at the law school, McKinley served as a US assistant attorney in San Francisco.

Matthew Sullivan, an 1876 graduate of St. Ignatius College, was a prominent San Francisco attorney, president of the alumni society, founding dean of the law school, and chief justice of the California Supreme Court.

Charles Wiseman graduated from the University of St. Ignatius in 1917 and immediately joined the US Navy. Many of his letters about his World War I military service were published in the *Ignatian*, the school's literary magazine.

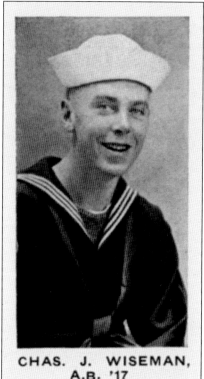

CHAS. J. WISEMAN, A.B. '17

Three former students from the University of St. Ignatius, as USF was then called, who were killed during the First World War were memorialized by gold stars on the university's service flag and in the June 1918 issue of the *Ignatian*.

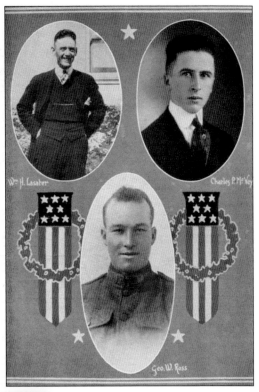

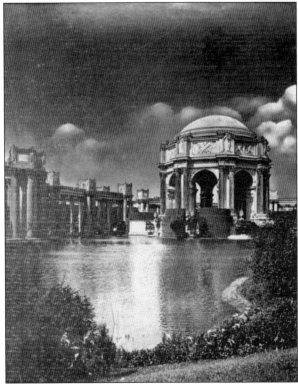

The Palace of Fine Arts is the sole survivor of the 32 plaster buildings erected for the 1915 Panama-Pacific Exposition, held in San Francisco while World War I raged in Europe. An editorial in the December 1915 issue of the *Ignatian* contrasted the horrors of war in Europe with the peaceful pursuits of the citizens of San Francisco, represented by the Panama-Pacific Exposition. The *Ignatian* included this photograph of the Palace of Fine Arts and some of the adjacent exposition buildings.

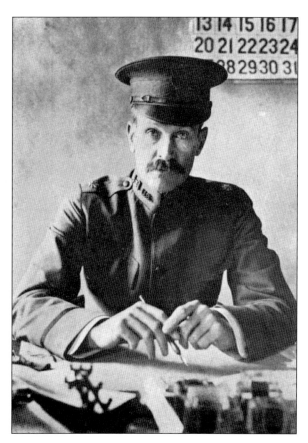

The November 1917 issue of the *Ignatian* published an honor roll of those former students from St. Ignatius College who were serving in the US military during World War I. Heading the list was the highest-ranking officer at that point in the war who graduated from the school: Brig. Gen. Charles McKinstry, St. Ignatius College class of 1884.

Richard Queen, St. Ignatius College class of 1912, was one of the many servicemen from World War I whose letters were published in the *Ignatian*. This photograph of First Sergeant Queen appeared in the June 1919 *Ignatian*.

Following the armistice on November 11, 1918, the *Ignatian* dedicated its June 1919 issue to the young men of St. Ignatius College and the University of St. Ignatius who served and died in World War I. Pictured here are some of the servicemen highlighted in that issue.

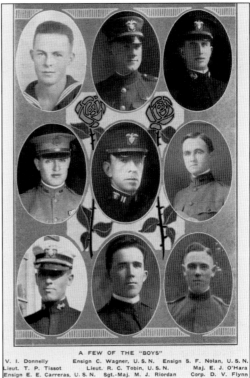

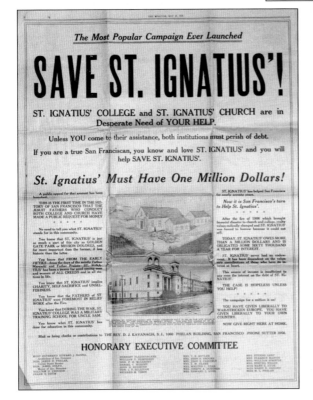

Several newspapers ran full-page advertisements calling upon the citizens of San Francisco to contribute to the campaign to save the church and college during its financial crisis following World War I. This advertisement appeared in the *Monitor*, a leading Catholic paper, on May 31, 1919.

Dennis Kavanagh, SJ, a well known pulpit orator and lecturer from St. Ignatius Church, directed the St. Ignatius Conservation League during its initial and successful efforts in raising money for St. Ignatius Church and College, which was on the verge of bankruptcy in 1919.

James Rolph Jr. (center), the mayor of San Francisco, played an active role in the efforts to rescue the church and college from its financial crisis of 1919. To the mayor's left is Pius Moore, SJ, president of St. Ignatius College; and to his right is Zacheus Maher, SJ, who graduated from St. Ignatius College in 1900 and later became the president of Santa Clara University, the president of Loyola University in Los Angeles, and provincial of the California Province of the Society of Jesus.

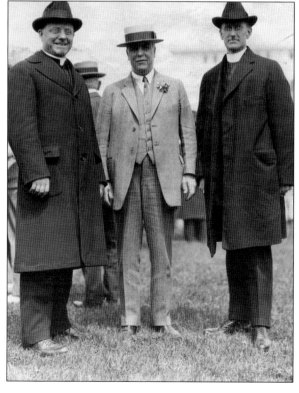

Nine faculty members from St. Ignatius College are pictured in the 1925 *Ignatian*. Two of them, Hubert Flynn, SJ, (second row, far left) and Alexis Mai, SJ, (first row, middle) later served as dean of the College of Arts and Sciences.

In the early 1920s, due in part to the expansion of the public transportation system, much of the property in the western portions of San Francisco was beginning to be developed in neighborhoods near St. Ignatius Church and College, as seen in this photograph from 1922.

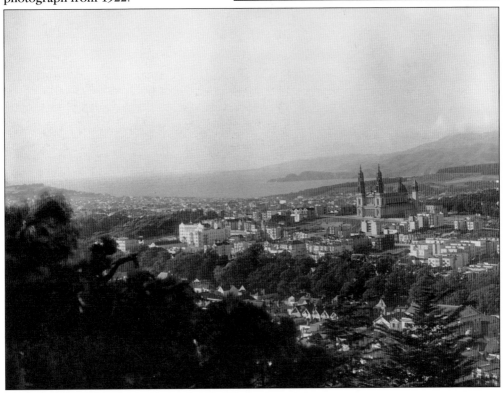

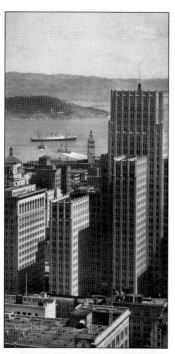

In 1925, the College of Commerce and Finance was established at St. Ignatius College. In the 90 years since its founding, the School of Management has produced graduates who have become leaders throughout the world. Some of those first graduates began their careers in the financial district of San Francisco, pictured here in the late 1920s. In the background is Treasure Island in the San Francisco Bay, prior to the construction of the Bay Bridge, completed in 1936.

Pictured here are two of the first female students to attend St. Ignatius College, in 1927. Anne Sullivan (left) was one of the first women in the evening division in the new College of Commerce and Finance. She was an officer in the French literary social club and was active in student government. Anne Shumway was a student in the School of Law, and she was elected vice president of her first-year law class.

The freshmen student officers of the new evening division are listed in the 1928 issue of the *Ignatian*, which includes photographs of class president John Riordan and vice president Margaret McAuliffe, one of the first women admitted to St. Ignatius College.

Since the 1920s, Filipino students have been a part of the ethnic diversity of the institution. In 1929, an organization named the Filipino Ignatians was founded in the College of Arts and Sciences. The photograph is of the officers of that organization, and it appeared in the *Ignatian* in 1929.

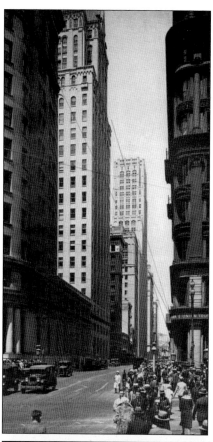

By the late 1920s, Montgomery Street in San Francisco, pictured here, was known as the "Wall Street of the West." Students from the new evening division at St. Ignatius College, especially in the College of Commerce and Finance, combined their professional careers in downtown San Francisco during the day with classes at night at the Jesuit institution.

Two leading debaters from St. Ignatius College in 1927 were Raymond Sullivan (left), who later became an associate justice of the California Supreme Court, and Preston Devine, who later became the presiding judge of the California Court of Appeals.

The *Ignatian* depicted some of the players in the Pageant of Youth, performed at the Civic Auditorium in San Francisco in 1925. In the center is Thomas Flaherty, SJ, St. Ignatius College faculty member and director of the pageant.

The 1924 *Ignatian* highlighted the star players from the St. Ignatius College basketball team, which won 14 of 18 games during the 1923–1924 season.

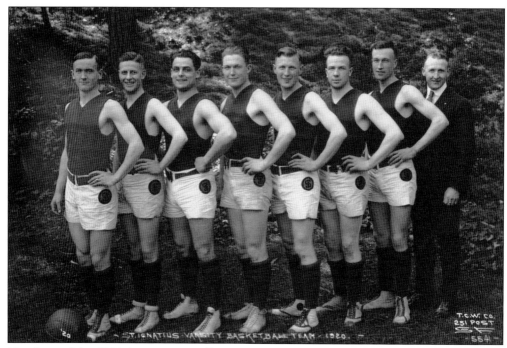

Members of the 1920 St. Ignatius College varsity basketball team are seen here. The squad lost only two league games on its way to a second-place finish in the California-Nevada Basketball League.

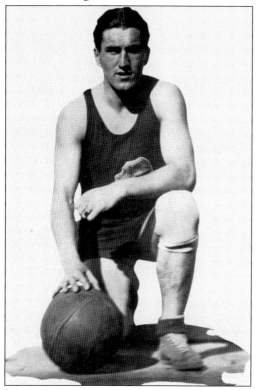

Pictured here is Raymond Maloney, All-American captain of the 1929 St. Ignatius College basketball team.

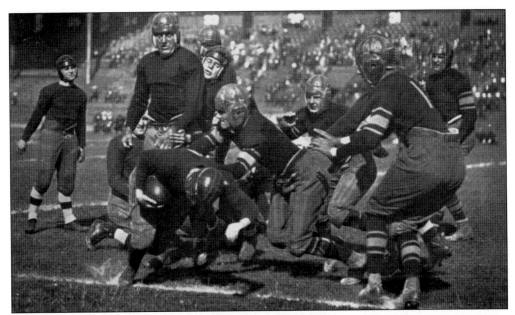

The St. Ignatius College football team is seen in action during the 1924 season, the college's first intercollegiate football team since 1917.

Jack O'Marie, two-time winner of the William S. Boyle Loyalty Award for outstanding play, was captain and star center for the St. Ignatius College football team in 1928 and 1929.

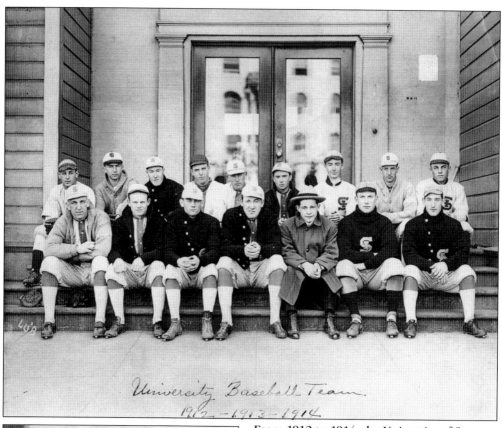

From 1912 to 1914, the University of St. Ignatius baseball team played many local amateur and college teams. In March 1913, the team narrowly lost an exhibition game to the Chicago White Sox, 4-2. Joe Giannini (first row, far right) was team leader during these years and eventually made it to the major leagues.

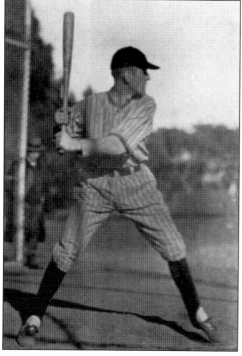

Pictured here at bat is Ray O'Connor, captain and star outfielder of the 1929 St. Ignatius College baseball team.

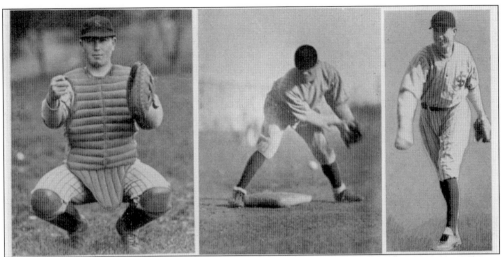

The 1929 St. Ignatius College baseball team included ace pitcher Joe Rock, catcher Gerald Vest, and third baseman George Maloney.

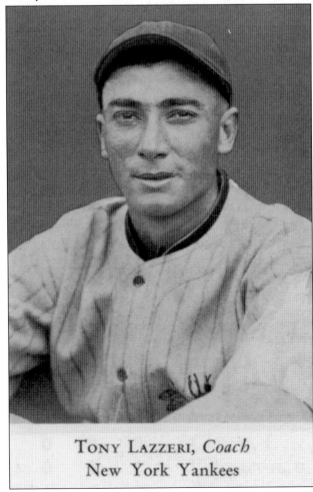

TONY LAZZERI, *Coach*
New York Yankees

Tony Lazzeri, star second baseman for the world-champion New York Yankees, teammate of Babe Ruth and Lou Gehrig, and native San Franciscan, coached the St. Ignatius College baseball team in the opening months of the 1928 season before he rejoined the Yankees. Lazzeri was later inducted into the National Baseball Hall of Fame.

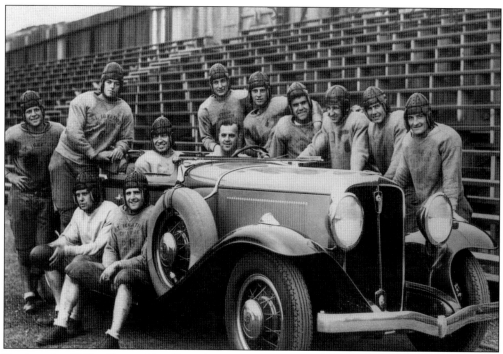

During the 1920s, Jimmy Needles (driver's seat) was a star player, coach, and eventually head coach for the St. Ignatius College basketball team. In 1928 and 1929, his teams won the West Coast basketball championship. Needles was also head coach for the college's football team, and in 1936, he coached the US Olympic basketball team to a gold medal in Berlin, Germany.

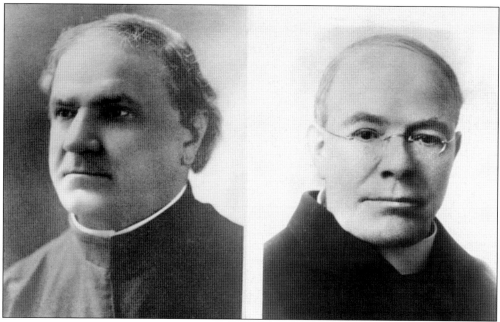

Joseph Sasia, SJ, (left) the institution's 13th president, served in that position from 1908 to 1911, and Albert Trivelli, SJ, the 14th president, held that office from 1911 to 1915.

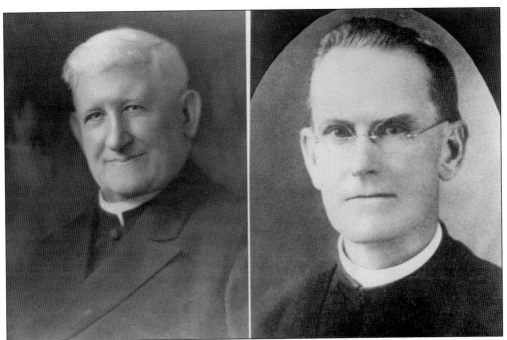

Patrick Foote, SJ, (left) served as the institution's 15th president, from 1915 to 1919, and Pius Moore, SJ, occupied the presidency from 1919 to 1925.

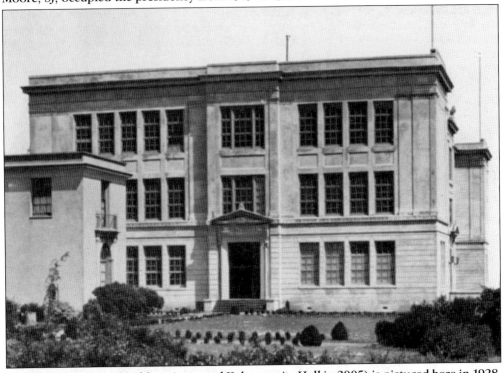

The new Liberal Arts Building (renamed Kalmanovitz Hall in 2005) is pictured here in 1928, the year after it was completed. The view is of the west side of the building, and to the left is a corner of the Jesuit residence (Welch Hall), which was demolished in 1970.

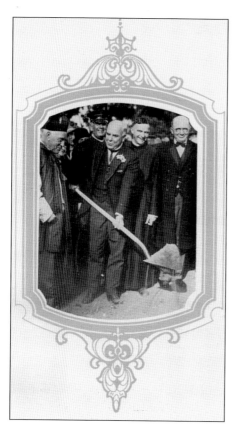

On December 10, 1926, a ground-breaking ceremony was held for the Liberal Arts Building (Kalmanovitz Hall). In this photograph from the *Ignatian*, James Rolph Jr., mayor of San Francisco, holds the ceremonial shovel. Edward Whelan, SJ, the president of St. Ignatius College, is behind and to the right of Mayor Rolph. Msgr. Michael Connolly, standing to the left of Mayor Rolph, represented the Archdiocese of San Francisco at the ceremony.

John McCummiskey, SJ, faculty member at St. Ignatius College and later dean of men, offered special masses to the hearing impaired of San Francisco using sign language and initiated training programs for diocesan priests to extend this work.

Four

SURVIVING THE DEPRESSION AND WAR

As the fall semester of 1929 got underway, the administration, faculty, students, and alumni of St. Ignatius College could look back to the prior decade with a great sense of accomplishment. Their institution had gone from the brink of bankruptcy in 1919 to economic stability in 1929; the campus had moved from a temporary wooden structure into a permanent home that boasted two new buildings; enrollment in the college division had dramatically increased from 194 students in 1919 to 1,099 in 1929; a new College of Commerce and Finance and an evening program had been successfully launched; the School of Law had grown in reputation and in enrollment; new curriculum areas had been developed; and the college's drama, debate, and athletic programs were flourishing, highlighted by the basketball team's capture of the 1929 Pacific Coast championship.

The success and growth of St. Ignatius College during the 1920s paralleled that of the city of San Francisco and the nation as whole. Innovations in technology, expansion in numerous industries, significant population growth, and high employment appeared to guarantee unending prosperity, limitless opportunities, and optimism about the future. Then came the stock market crash of October 1929. Within a matter of days, $30 billion was lost, and the economy of the United States and much of the world was shaken to the core. Although only a relatively small percentage of the US population was directly affected by the stock market crash, the market's collapse set in motion economic forces that soon led to massive layoffs, business closings, and bank failures that eliminated the life savings of tens of thousands of people. In 1930, the United States saw 26,000 businesses close their doors, followed by another 28,000 business failures in 1931. By 1932, almost 3,500 banks had gone under, eliminating billions of dollars in uninsured deposits. Nearly 25 percent of the labor force, about 12 million people, lost their jobs, and those who kept their jobs saw their real earnings fall by 33 percent. The collapse of the US economy ushered in what soon became known throughout the world as the Great Depression.

The worldwide depression had major effects on the nation, the city of San Francisco, and the university that would soon adopt the city's name. Like the city itself, the Jesuits' experiment in education faced major economic challenges during the 1930s—finances

were a constant source of concern, and enrollment was flat during most of the decade. The institution began the decade, however, on several optimistic notes, including a celebration of its 75th anniversary, a new name, and a US Supreme Court decision paving the way for a major land acquisition that encompassed part of an old Masonic cemetery and extended the campus north to Golden Gate Avenue, east to Masonic Avenue, and west to Parker Avenue. The shortage of cash during the Depression did, however, prevent USF from purchasing that portion of the cemetery that ran all the way to Turk Street and from building on the land that it did acquire. The cocurricular programs that had flourished during the 1920s, including athletics, drama, and debate, survived the economic woes of the 1930s, though desperately needed improvements for the library, science equipment, and classroom facilities were financially impossible. Graduates of the university found the job market terrible, and alumni contributions were minimal.

Concurrent with the beginning of a national economic recovery by 1939, World War II erupted in Europe and Asia, finally engulfing the United States, as well, on December 7, 1941. During the war, the University of San Francisco saw its enrollment plummet to fewer than 400 students, as most of the student body volunteered for the armed forces or were drafted. Former USF students fought all over the globe and in every branch of the service. Many were wounded, and more than 100 former USF students lost their lives. At USF, monthly deficits soared, and had it not been for the establishment of a military training program on campus and a modest but ultimately crucial fundraising campaign, the institution might have closed its doors before the war finally ended on August 16, 1945. Once again, however, the university survived external threats largely through the resourcefulness of its leaders, including its president, William Dunne, SJ. With the end of the war, a new era of expansion and challenges was at hand. The sacrifices of those who did not return from the war, however, were not forgotten by the nation or by San Francisco's Jesuit institution of higher education.

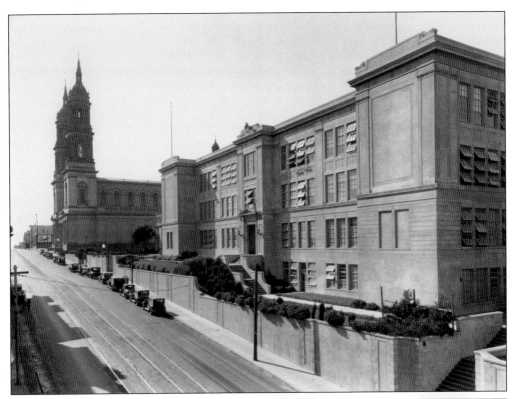

The University of San Francisco is pictured here in 1930, the year the institution changed its name from St. Ignatius College. A corner of the Jesuit residence (Welch Hall) can be seen peeking out from between Campion Hall and St. Ignatius Church.

Pictured here in 1931 is the main gateway to the University of San Francisco, up the steps from Fulton Street. If visitors to the campus in 1931 passed through this gate, they would first come to the Jesuit residence (Welch Hall). To their left would be St. Ignatius Church, and to their right, the Liberal Arts Building (Kalmanovitz Hall). Until 1950, these were the only three permanent buildings on campus.

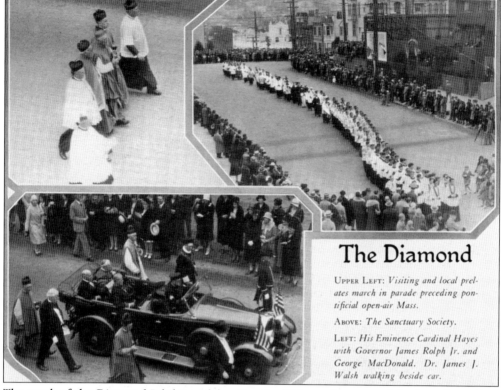

The Diamond

UPPER LEFT: *Visiting and local prelates march in parade preceding pontifical open-air Mass.*

ABOVE: *The Sanctuary Society.*

LEFT: *His Eminence Cardinal Hayes with Governor James Rolph Jr. and George MacDonald. Dr. James J. Walsh walking beside car.*

The week of the Diamond Jubilee, celebrating the 75th anniversary of the founding of St. Ignatius Church and College, was held October 12–19, 1930. The occasion was used to announce that the name of St. Ignatius College was to be changed to the University of San Francisco. The last day of the Diamond Jubilee included a parade of civic, religious, and fraternal leaders and organizations. Seated in the rear seat of this parade car are (passenger's side) James Rolph Jr., mayor of San Francisco, and (driver's side) Cardinal Patrick Hayes of New York, who delivered the sermon at an outdoor mass following the parade.

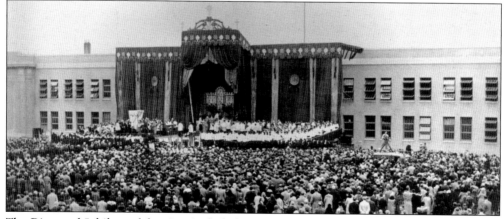

The Diamond Jubilee celebration included an open-air mass on campus before a colossal altar. The mass was held at the St. Ignatius High School Stadium, the current site of Negoesco Stadium, adjacent to what is now the Koret Health and Recreation Center of the University of San Francisco.

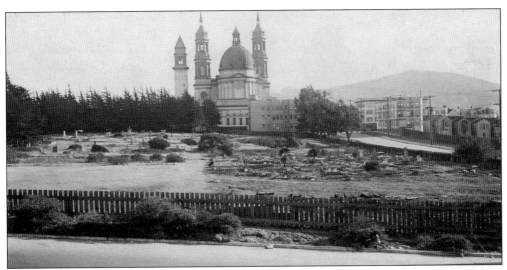

After years of litigation and negotiations, approximately 14 acres of the Masonic Cemetery, situated just north of Campion Hall and St. Ignatius Church, was purchased by USF in 1934. This photograph was taken on October 14, 1930, during USF's Diamond Jubilee celebration. (Courtesy of the San Francisco History Center, San Francisco Public Library.)

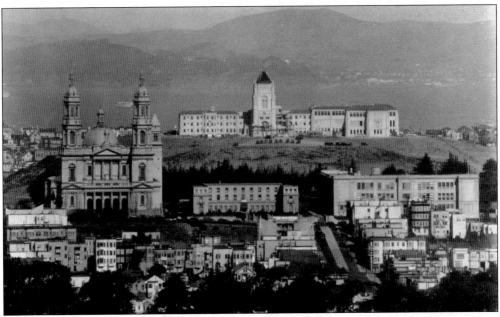

Pictured here in 1932 is the University of San Francisco, two years after it adopted that name. The institution began as St. Ignatius Academy in 1855, changed its name to St. Ignatius College in 1859, became the University of St. Ignatius in 1912, reverted to St. Ignatius College in 1919, and became the University of San Francisco in 1930. In 1932, the only three buildings on campus were St. Ignatius Church, the Jesuit residence (Welch Hall) to the right of the church, and the Liberal Arts Building (Kalmanovitz Hall) to the right of the Jesuit residence. In the background is Lone Mountain, with the just-completed San Francisco College for Women perched on top. The University of San Francisco purchased Lone Mountain from the Religious of the Sacred Heart in 1978.

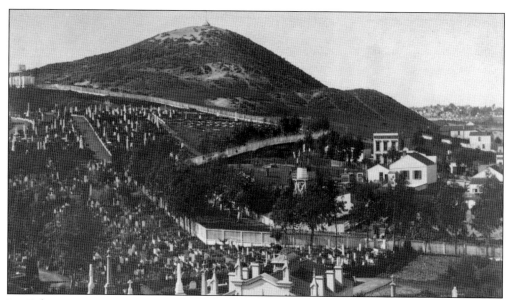

In 1861, Lone Mountain was a Catholic cemetery for gold miners, silver barons, wealthy businessmen, and politicians. Today, it is the site of the Lone Mountain campus of the University of San Francisco.

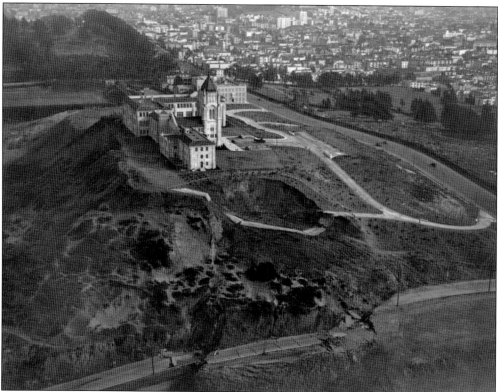

This aerial photograph of Lone Mountain and the San Francisco College for Women was taken on December 26, 1935, immediately after a landslide brought part of the mountain down onto Parker Avenue.

The management of the first student newspaper of St. Ignatius College included, from left to right, Edward McQuade (editor), James Smyth (business manager), and John Lounibos (associate editor).

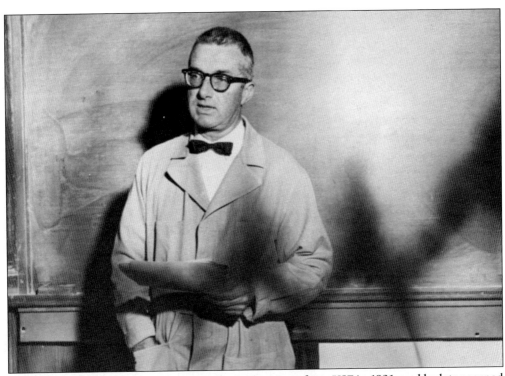

Mel Gorman received a bachelor's degree in chemistry from USF in 1931, and he later earned a master's degree in science from the University of California, Berkeley, and a doctorate in chemistry from Stanford University. Professor Gorman conducted research, published extensively, taught chemistry at USF for 46 years, and in 1967, received USF's first distinguished teaching award.

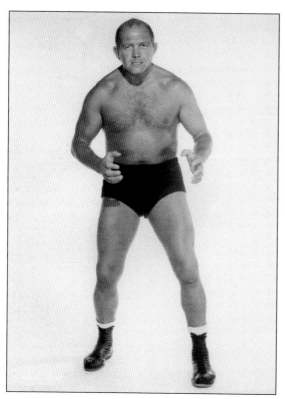

Tom Rice played football (he was an All-Coast tackle) and rugby for USF from 1936 to 1939. In the 1950s, he was a professional wrestler (pictured here) under the name of the Red Scorpion, the Red Phantom, and the Masked Marvel. He was a major supporter of his alma mater, and for decades he devoted much of his time to university advancement, where he was known as the "Generator."

Earl Booker, who received a bachelor's degree in history from USF in 1941, won the Intercollegiate Boxing Championship in 1936.

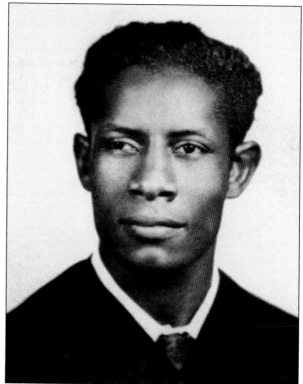

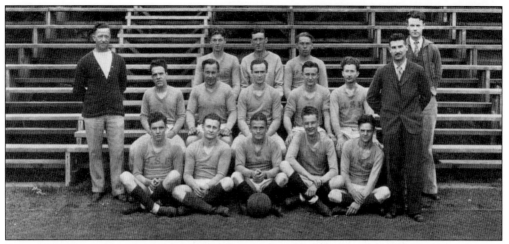

The 1931 USF soccer team, in its second year of intercollegiate competition, tied Stanford University for the Pacific Coast League championship.

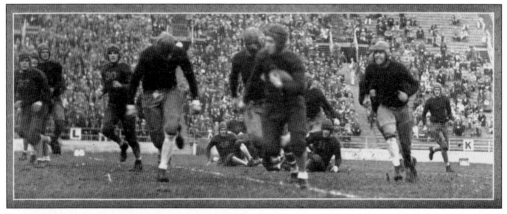

During the 1930 football season, the USF football team defeated Loyola University of Los Angeles 14-0 at Wrigley Field in Los Angeles.

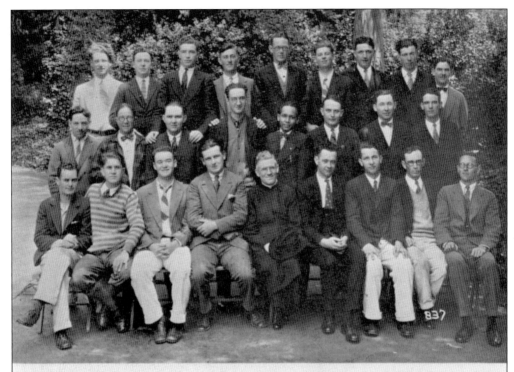

Top: KITTERMAN, SULLIVAN, DEASY, MORTON, JORDAN, WARD, HETTICH, MCCORMACK, SMITH.
Second: GUARDINO, JOSEPH, WEYAND, JACOBS, LOPEZ, KIRBY, MCHUGH, MCQUADE.
First: BARRETT, HIRSCHBERG, MURPHY, BOLAND, FR. GEARON, S.J., KENNEALLY, HUBNER, CONNOLLY, DYER.

Pictured here is the College of Arts and Sciences' sophomore class in 1926, the year after the college was officially formed. In the first row on the far left is John Barrett, the class president, and in the middle of the front row is John Gearon, SJ, one of the college's professors.

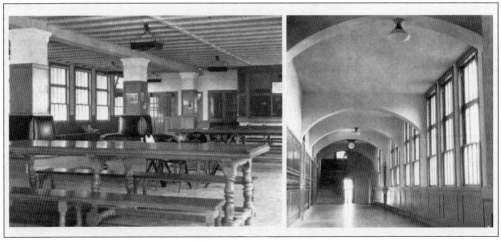

Pictured here are two views of the new wing to the Liberal Arts Building (renamed Kalmanovitz Hall in 2005), which opened in 1931, the year before Father Whelan left the presidency of USF: a second-floor hallway (right) and the student lounge.

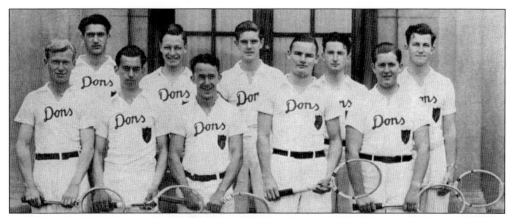

Despite the Great Depression of the 1930s, USF managed to find the economic resources to sustain its athletic programs, including varsity football, basketball, baseball, rugby, boxing, soccer, golf, and tennis. Pictured here is the 1937 USF varsity tennis team.

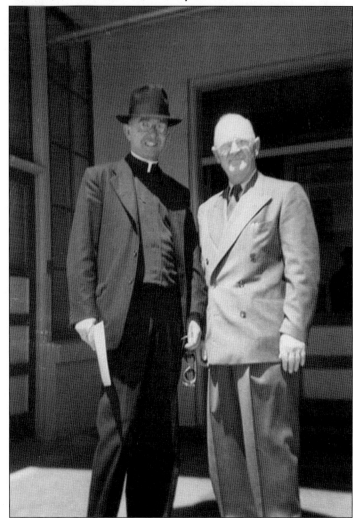

During the 1930s, Joseph Clark, SJ, science professor at USF, was among the first Catholic chaplains at Alcatraz Federal Prison in the San Francisco Bay. He built a chapel for the inmates and referred to himself as "Convict" Clark. This photograph of Father Clark (left) and associate warden Paul Madigan was taken at Alcatraz in 1948. (Courtesy of the California Province of the Society of Jesus.)

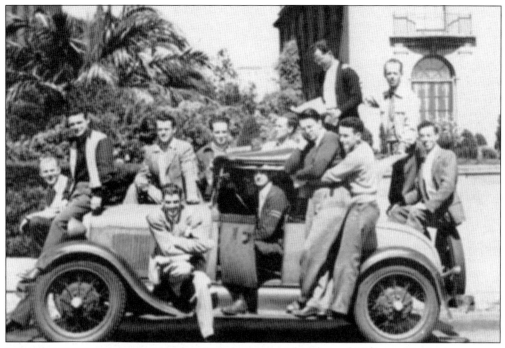

The class of 1941 was the last USF class to graduate before the United States entered World War II. In this photograph, some members of that class pose in front of the Jesuit residence (Welch Hall) on the USF campus.

Members of a USF ROTC unit stand at attention in front of St. Ignatius Church in 1942. During World War II, more than 3,000 former students and faculty members of St. Ignatius High School and USF (the two schools were joined until 1959) served in all branches of the military, and 136 former students lost their lives. In Abraham Lincoln's immortal phrase from the Civil War, they gave "the last full measure."

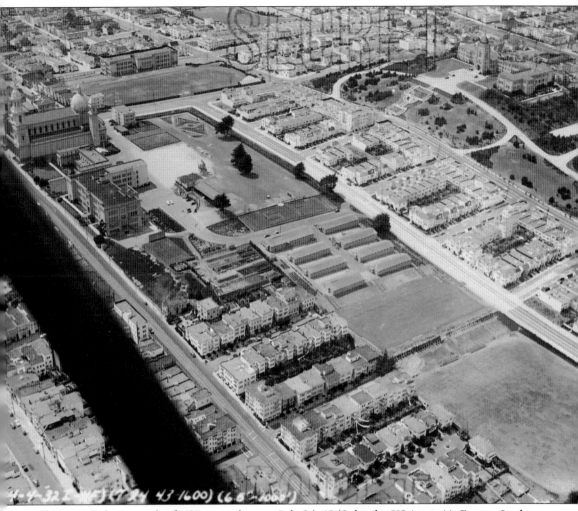

This aerial photograph of USF was taken on July 24, 1943, by the US Army Air Forces. In the upper left are St. Ignatius Church, the Jesuit residence (Welch Hall), and the Liberal Arts Building, the only permanent buildings on campus at the time. In the upper right, situated on the top of Lone Mountain, is the San Francisco College for Women. The eight one-story buildings in the middle of the photograph (along Golden Gate Avenue) are barracks, offices, and an infirmary for approximately 300 students in the Army Specialized Training Program (ASTP).

In this 1942 photograph, an ROTC student is seated on a cemetery monument on the USF campus. The monument was removed by the end of World War II. In the background is St. Ignatius Church, completed in 1914. During World War II, the church was a navigation point for naval vessels entering the San Francisco Bay and a beacon of hope for many servicemen aboard ships bound for war in the Pacific Ocean.

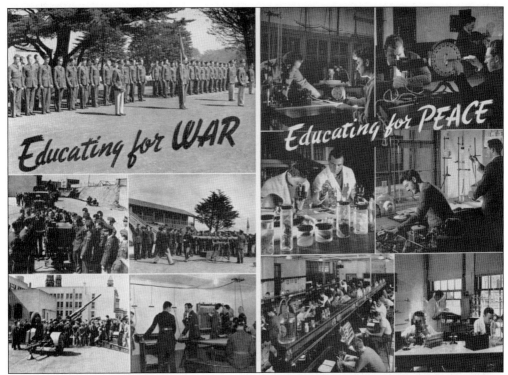

A pamphlet published by the University of San Francisco in 1945 highlighted the school's educational aims, reprinted the USF credo, included a number of historical photographs of the institution, and with World War II coming to an end, featured a two-page spread on the university educating for war and peace.

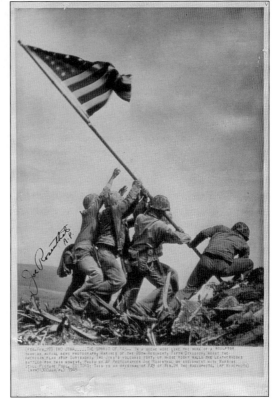

On February 23, 1945, Joe Rosenthal, AP photographer and former USF student, took what was arguably the most famous photograph of World War II: the raising of the American flag on Iwo Jima in the midst of the battle against the Japanese for that strategically important island. Rosenthal won the Pulitzer Prize for photography in 1945 for the photograph. (Courtesy AP/Wide World Photos.)

William Dunne, SJ, 20th president of the University of San Francisco, served in that capacity longer than any other man. During his administration, from 1938 to 1954, USF successfully adapted to worldwide economic depression and war, accommodated a postwar upsurge in enrollment, witnessed a major building campaign, and launched a host of new academic programs, including master's degrees in history, chemistry, and biology.

William Dunne, SJ, president of the University of San Francisco (right), shakes hands with Harry S. Truman, president of the United States, during the founding of the United Nations in San Francisco in April 1945. Standing between Father Dunne and President Truman is Edward Stettinus, the secretary of state and later the country's representative to the United Nations.

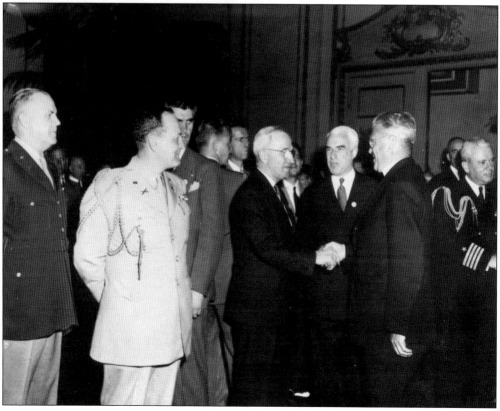

Five

The Postwar Era through the 1960s

Following the end of World War II, veterans returned to the nation's colleges and universities in vast numbers, thanks in large part to the GI Bill of Rights. The student population grew rapidly at the University of San Francisco, and several new programs and buildings were planned and completed between 1945 and 1969. The buildings included Gleeson Library; War Memorial Gymnasium; Xavier Hall, a new residence for the Jesuit community; Kendrick Hall, the new home of the School of Law; Harney Science Center; University Center; Cowell Hall, the new location for the School of Nursing; and Phelan, Gillson, and Hayes-Healy residence halls.

During the postwar era, the College of Arts and Sciences, the School of Law, and the College of Business Administration all witnessed rapid increases in student enrollment and major curriculum changes. In 1947, USF started a department of education for the certification of teachers, which developed into the School of Education by 1972 with the addition of numerous graduate programs. In 1948, a nursing program was initiated at USF in cooperation with St. Mary's Hospital, and by 1954, it had developed into an autonomous School of Nursing, now known as the School of Nursing and Health Professions. A full-fledged graduate division and an evening college were also initiated at USF in the immediate postwar era to accommodate changing educational, professional, and social needs.

The postwar years saw a revival of the athletic programs at the university, and the institution developed a West Coast and national reputation in several sports. In basketball, USF won national championships in 1949, 1955, and 1956, and players such as Bill Russell and K.C. Jones became household names. The 1951 USF football team was one of the best intercollegiate football teams that ever played—it had an undefeated and untied season and would have gone on to a postseason bowl game were it not for prevailing national racism, which precluded the team and its star African American players, Ollie Matson and Burl Toler, from postseason participation. The 1950 USF soccer team also faced racism, but nevertheless, players went to the first intercollegiate soccer bowl game ever played and emerged as national cochampions. From 1945 to 1960, the USF soccer team, under coach Gus Donoghue, won 11 conference championships, and under Steve Negoesco, who took over as head coach in 1962, the

soccer team brought back 13 conference championships and four national titles. Coach Negoesco led his teams to more victories than any other coach in the history of the game in the United States.

Three presidents guided the fortunes of the University of San Francisco from 1945 to 1969: William J. Dunne, SJ, whose tenure stretched back to 1938; John F.X. Connolly, SJ; and Charles W. Dullea, SJ. These Jesuits worked mightily to secure the fiscal and human resources needed to support the university's expansion. They oversaw numerous academic changes at the institution and shared in the growing reputation of USF as a leading institution of higher education. In 1964, women were admitted for the first time to the regular day division of the university, though women had been pursuing degrees at night in law, business, and the arts since the late 1920s, in nursing beginning in 1948, and in education since the early 1950s. Fathers Connolly and Dullea presided over the institution during the 1960s, a turbulent era for the nation's colleges and universities, and USF was not immune to the social, political, and cultural upheaval sweeping the nation.

An ROTC Color Guard leads graduates from the Liberal Arts Building (Kalmanovitz Hall) past Welch Hall to St. Ignatius Church for baccalaureate mass during the 90th commencement ceremonies for USF, held on June 5, 1949. The immediate postwar years witnessed phenomenal enrollment growth at the university, fueled in part by the GI Bill of Rights, one of the most significant pieces of legislation in the history of the nation.

Two members of the first USF Board of Regents, Dr. Edmund Morrissey (left) and Vincent Compagno, are pictured at a fundraising event in 1947, the year that William Dunne, SJ, president of USF, established the board of regents. In the upper right of the photograph is Richard Egan, actor and 1943 graduate of USF.

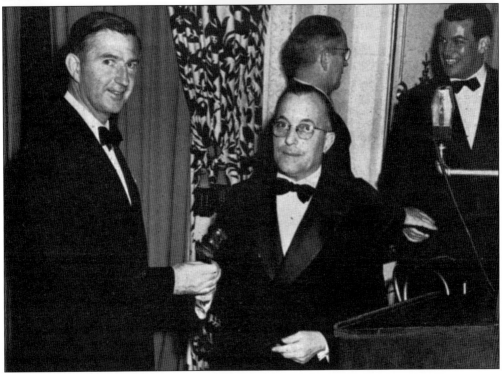

Gleeson Library is pictured here in 1950, the year it was dedicated.

The Jesuit residence (Welch Hall) is pictured here in the early 1950s, shortly after Gleeson Library (seen directly in back of Welch Hall) was completed. To the left of Welch Hall is St. Ignatius Church, and to the right is the Liberal Arts Building.

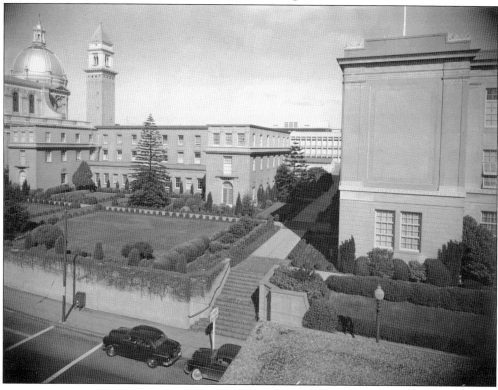

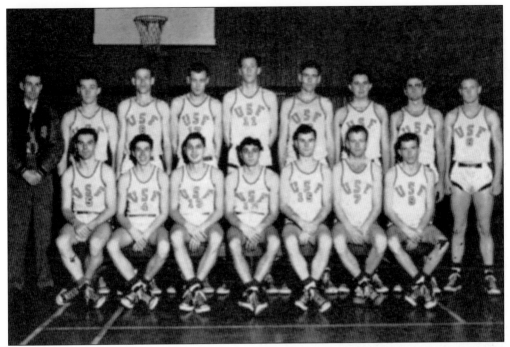

The 1949 USF basketball team won the National Invitational Tournament (NIT), considered the national championship of the era.

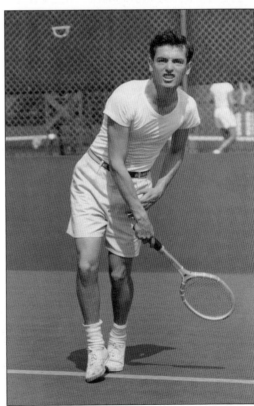

Harry Likas won USF's first individual NCAA title in 1948. The next year, the USF tennis team won the NCAA championship.

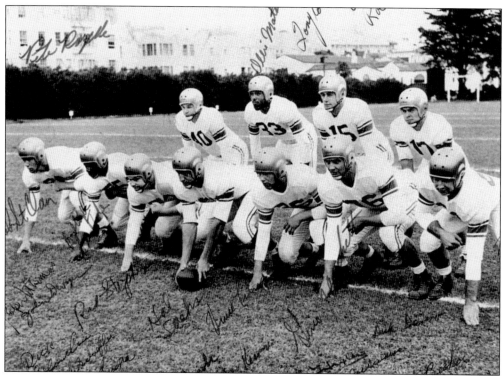

The USF football team of 1951 was undefeated on the gridiron and had nine of its players drafted by the NFL. Three of those players (Ollie Matson, Gino Marchetti, and Bob St. Clair) were eventually inducted into the Pro Football Hall of Fame. Despite fielding perhaps the best collegiate football team of all time, the Dons were not invited to play in any postseason bowl games unless they left their African American players (Ollie Matson and Burl Toler) at home. The team refused, stood on principle, and transcended the segregated and racist temper of the times.

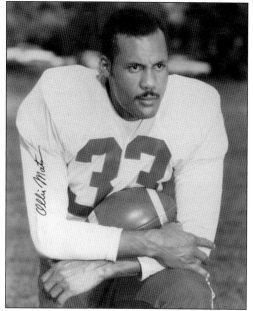

Ollie Matson was fullback for the undefeated USF football team of 1951. He was the nation's leading intercollegiate rusher and scorer in football during that season, was selected to be a member of *Look* magazine's All-America team, won silver and bronze medals in track at the 1952 Olympics, had a spectacular career in professional football, and was inducted into the Pro Football Hall of Fame.

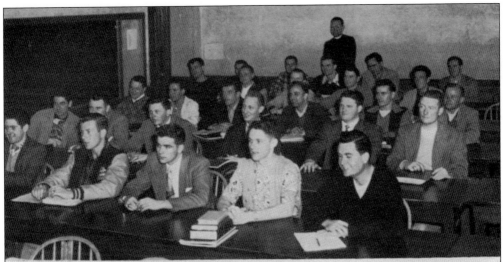

Pictured above is the first group of men in the undergraduate division to take the course in the History of San Francisco now being offered by the University. In the background, Rev. John B. McGloin, S.J., noted author, who conducts the attractive and popular course.

In 1950, a course on the history of San Francisco was first offered by the eminent historian John McGloin, SJ, standing in the back of the classroom.

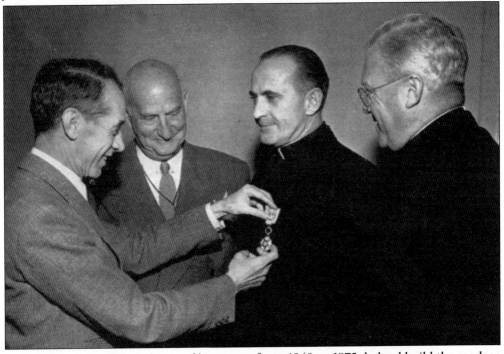

P. Carlo Rossi, SJ, USF professor of languages from 1940 to 1975, helped build the modern languages department in the College of Arts and Sciences during the postwar years. In 1949, he was awarded the Order of the Southern Cross for furthering cultural relations between Brazil and the United States. At the award ceremony are, from left to right, Jose Fabrino de Oliveira Baiao, consul general of Brazil; William Geiger, director of the Department of Public Health in San Francisco and former recipient of the award; Father Rossi; and William Dunne, SJ, president of the University of San Francisco.

Edmund Smyth, SJ, was dean of the College of Arts and Sciences from 1955 to 1967. He developed a reputation for knowing the name of every student in the college.

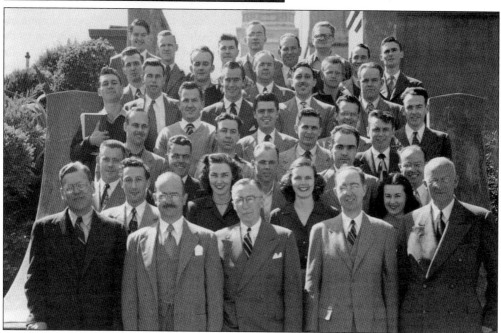

The USF School of Law class of 1949 and some of their professors are pictured here on the stairs of Campion Hall. In the first row, from left to right, are Professors William deFuniak, E.L. Merica, and Charles Knights, Dean Edward Hogan, and Prof. C.F. Stanley. In the second row, second from the left, is librarian Elizabeth Anne Quigley.

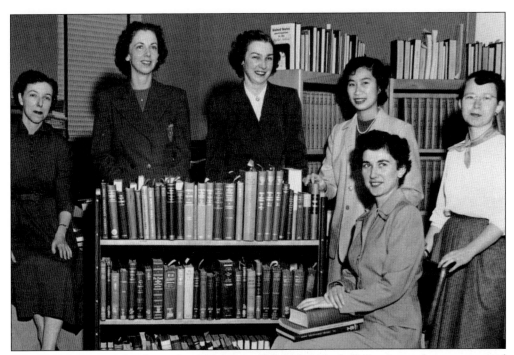

Elizabeth Anne Quigley, law school librarian (third from the left), is pictured among several librarians from the Gleeson Library in the early 1950s. The School of Law was housed on the third floor of the Gleeson Library from 1950 to 1962.

During the 1953–1954 academic year, accounting student Dominic Tarantino served as Associated Students of the University of San Francisco (ASUSF) president. After graduation, he pursued an accounting career, rising to become chairman of Price Waterhouse World Firm Limited. He later served on the USF Board of Trustees, chairing it from 1999 to 2003. He has been a major supporter of his alma mater.

Pictured here is Edward Griffin, the first dean of USF's School of Education, which was established in 1972, twenty-five years after USF's Department of Education began preparing teachers for California's schools.

Katherine Bishop was the first director of the teacher education credential program at USF for elementary school teachers.

Katherine V. Bishop, Ed. D.
Director Elementary Education and Assistant Professor

In 1954, when the USF School of Nursing was established, starched blouses, pinafores, and caps were required of nursing students such as Sandy Mooring, pictured here. Nurses had not yet attained the status they enjoy today as health care leaders. Ove r the past 50 years, the USF School of Nursing has significantly contributed to the enhancement of the profession. It is now known as the School of Nursing and Health Professions.

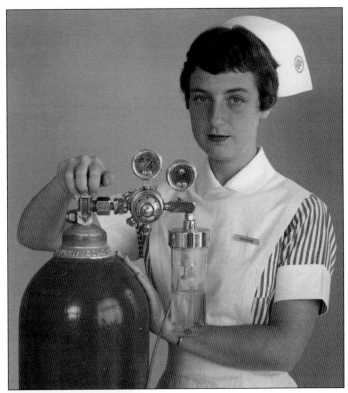

John Martin, SJ, served as the first dean of USF's graduate division, which was established in 1949 and offered master's degrees in biology, chemistry, and history.

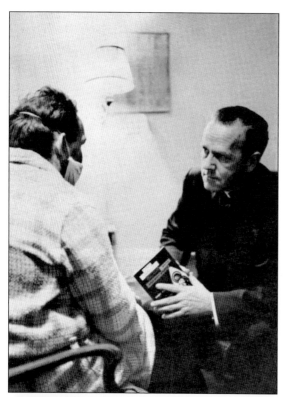

Gerald Fader, SJ, from the USF Jesuit community, is pictured here counseling a tuberculosis patient at the City and County Hospital of San Francisco in 1955. Father Fader continued a tradition that stretched back to Ignatius of Loyola's ministry to the hospitalized of Rome in the mid-16th century and found expression in San Francisco with the coming of the Jesuits in the mid-19th century.

William Monihan, SJ, USF's head librarian, led the efforts to establish a new university library named in honor of Fr. Richard Gleeson. In this photograph, Father Monihan (right) is meeting with architect Milton Pflueger in 1950 to go over plans for a scale model of the library, the first new construction on the campus since 1927.

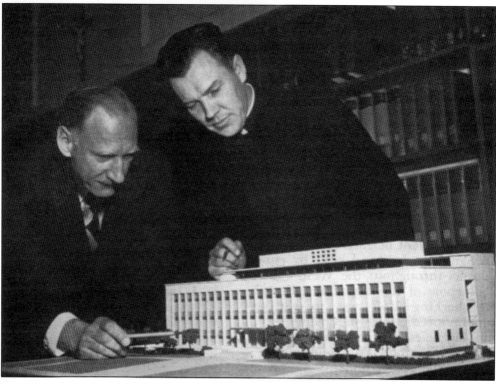

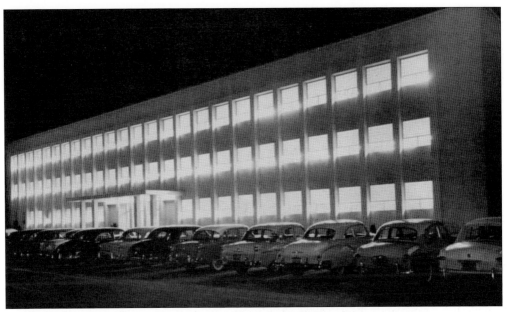

During the 1950s, the new Gleeson Library successfully accommodated the educational needs of growing number of evening students on the USF campus.

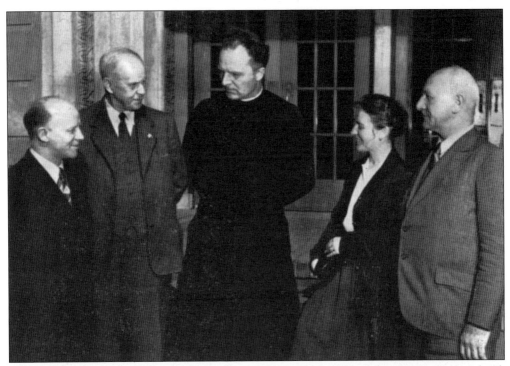

George Lucy, SJ, (center) director of both the evening division and the Labor Management School, is shown here with four trade union leaders from Germany who visited USF in 1950.

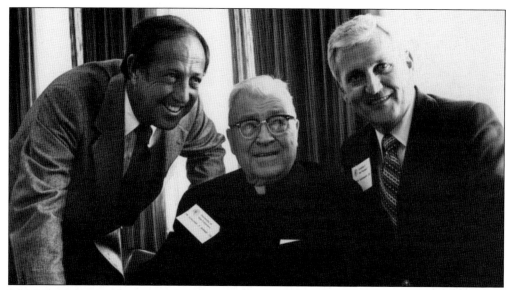

In 1979, Father Dunne, president emeritus of USF, met with Pete Rozelle (left), class of 1950, former USF sports information director, and commissioner of the NFL. Also pictured is Al Alessandri (right), who graduated from USF in 1950 and later served as president of the alumni association, vice president for university relations, and special assistant to the president at USF.

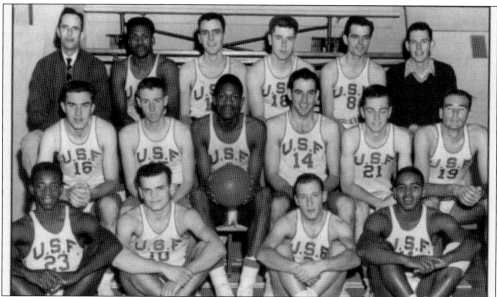

The 1954–1955 USF basketball team won the NCAA Championship and began a 60-game winning streak that led to another NCAA Championship during the 1955–1956 season. The winning streak extended partway into the next season and established a new NCAA record up to that time. It is still the second-longest winning streak in NCAA history. Members of the 1955 championship team are pictured here. From left to right are (first row) Hal Perry, Steve Balchios, Rudy Zanninin, and Warren Baxter; (second row) Tom Nelson, Stan Buchanan, Bill Russell, Jerry Mullen, Jack King, and Bob Wiebusch; (third row) coach Phil Wolpert, K.C. Jones, Dick Lawless, Gordon Kirby, Bill Bush, and team manager Ray Healy.

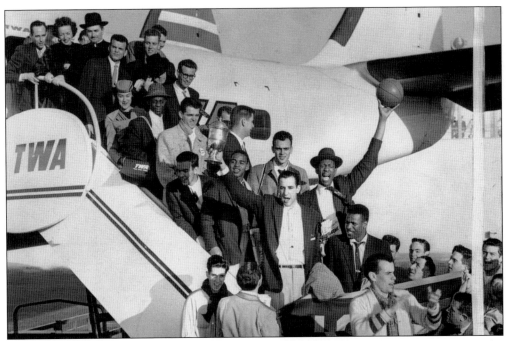

The 1954–1955 Dons exit their flight with championship trophy in hand after winning the NCAA basketball tournament. Coach Wolpert is at the far left at the top of the stairs.

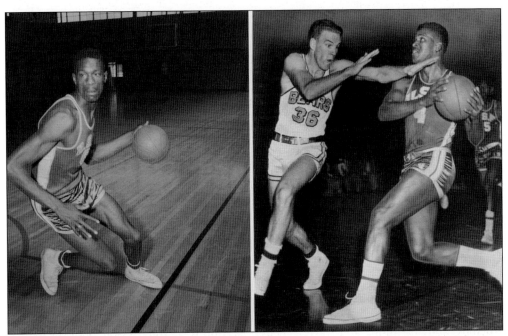

Pictured here are Bill Russell (left) and K.C. Jones in action during the 1955–1956 NCAA championship season.

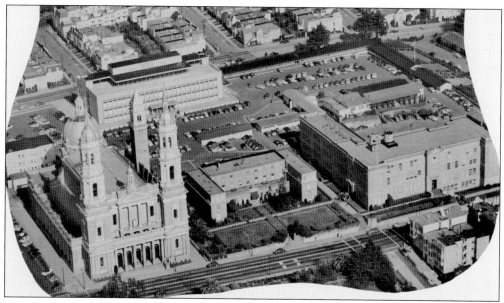

The University of San Francisco celebrated its centennial in 1955. St. Ignatius Church, completed in 1914, is in the lower left of the photograph, and to its right is Welch Hall (the Jesuit residence), built in 1921 and torn down in 1970. To the right of Welch Hall is the Liberal Arts Building, built in 1927, and later renamed Campion Hall and then Kalmanovitz Hall. In 1955, the Liberal Arts Building housed all of USF's academic programs except for the School of Law, which was on the third floor of Gleeson Library, completed in 1950, just north of Welch Hall. Some classes were held in barracks left over from World War II, as seen in the upper right of this photograph. Phelan Hall, under construction in 1955, is outside of this image to the right. The Harney Science Center was not built until 1965, on the site of the parking lot to the right of Gleeson Library. The rest of the campus as we know it today was still in the planning or dreaming stage.

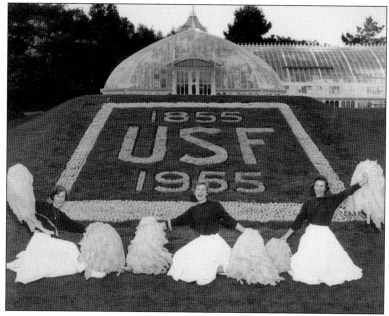

The university cheer girls celebrate the institution's centennial in front of the Golden Gate Park Conservatory.

Gus Donoghue captained the USF soccer team to four consecutive Pacific Coast Soccer League championships from 1932 to 1936, was a three-time All-American player, and was elected student body president. After serving in the Navy during World War II, Donoghue returned to USF to teach history, serve as director of admissions, and coach the soccer team to 11 consecutive Northern California Intercollegiate Soccer Conference titles and a national cochampionship.

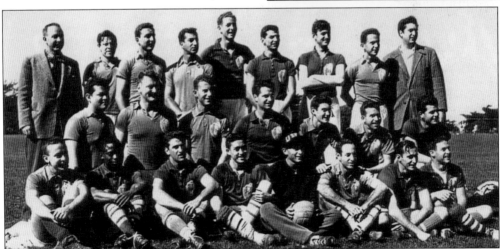

The 1950 USF Soccer team was declared national cochampions after tying Penn State in the first annual intercollegiate soccer bowl game. In this photograph, coach Gus Donoghue is standing in the third row on the far left, and star player and future coach Steve Negoesco is fourth from the left in the second row.

Steve Negoesco is the all-time leader among NCAA soccer coaches in games won, with 544 victories over 39 seasons, including 13 West Coast Conference championships and four national titles. He also played on the 1949 USF soccer team that won a national cochampionship. In 2003, he was inducted into the National Soccer Hall of Fame.

John Connolly, SJ, served as the 21st president of the University of San Francisco, from 1954 to 1963, and as provincial of the California Province of the Society of Jesus from 1963 to 1968. During his presidency, USF underwent a major building campaign, increasingly reached out to the community with social programs, and celebrated its centennial.

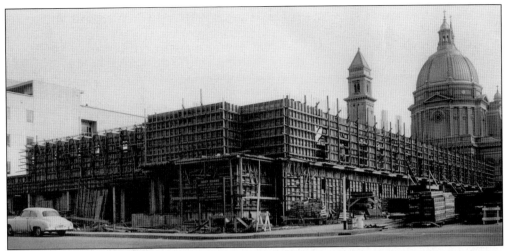

Xavier Hall, seen here under construction in 1958, was completed during Father Connolly's presidency. It served as the home of the Jesuit community from 1959 until 1999, when Loyola House was built on Lone Mountain as the new home for the Jesuits. Xavier Hall later became a residence hall for students and home for the visual arts department and its classroom studios. In 2003, Xavier Hall was remodeled and renamed the Alfred and Hanna Fromm Lifelong Learning Center.

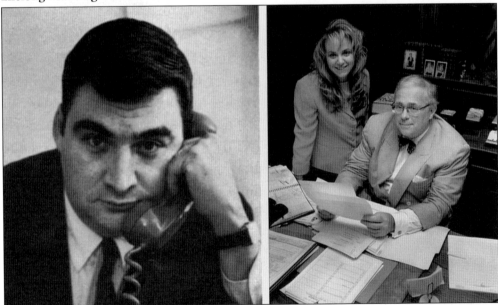

Pierre Salinger (left), pictured here in 1960, was a reporter for the *Foghorn* and the *San Francisco Chronicle* while a student at USF. He became the editor at the *Chronicle*, worked for *Collier's* magazine, was press secretary for Pres. John F. Kennedy, and served as ABC bureau chief in Paris. Kevin Starr (right), pictured here in 1998, was editor of the *Foghorn* when it won a Pacemaker Award as the best college publication in the nation. He later became a professor in the communication arts department at USF. He went on to become University Professor of History at the University of Southern California and the state librarian of California. He is the author of *Americans and the California Dream* and numerous other books and articles on California's intellectual and cultural history.

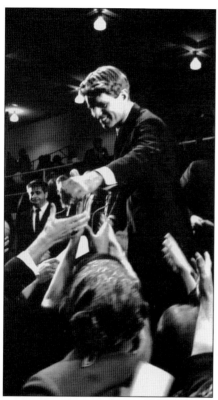

Sen. Robert Kennedy spoke to a capacity crowd in USF's War Memorial Gymnasium on April 19, 1968, during his California campaign for the presidency. He called for an end to the Vietnam War and action on behalf of the poor. Less than two months after his speech at USF, he was assassinated.

John Lo Schiavo, SJ, the dean of students in 1963, surveys the center of campus from atop Xavier Hall. Temporary structures, including World War II Quonset huts, still occupied part of the campus.

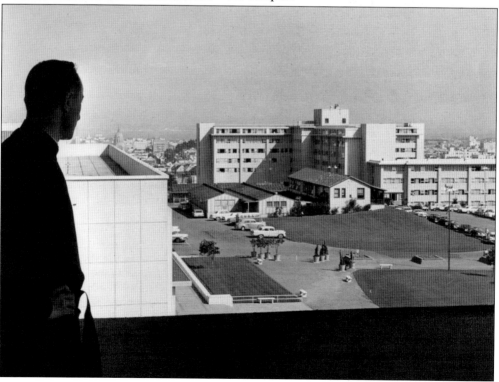

In 1962, the Student Western Addition Project (SWAP) was founded under the guidance of Ralph Lane, USF sociology professor. Pictured here is the 1968 SWAP steering committee. From left to right are (first row) Bob Downey and Neil MacIntyre; (second row) John Howe, Mary Spohn, Leanna Burke, and Margie Ryan; (third row) Chuck Riffle (holding onto the sign), Charlie Martinez, and Bob Giddings.

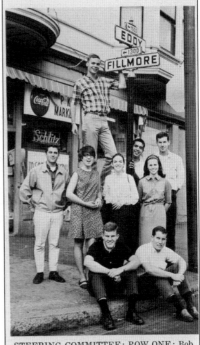

STEERING COMMITTEE: ROW ONE: Bob Downey, Neil MacIntyre. ROW TWO: John Howe, Mary Spohn, Leanna Burke, Charlie Martinez, Margie Ryan, Bob Giddings. ROW THREE: Chuck Riffle.

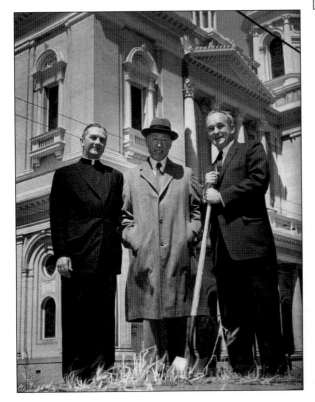

On May 23, 1961, a groundbreaking ceremony was held for Kendrick Hall, the new home of the USF School of Law. Pictured here are John Connolly, SJ, (left) the president of the University of San Francisco, and Francis Walsh (right), dean of the School of Law. Charles Kendrick (center), chairman of the president's council of advisers, made a gift of $1 million to the university, the foundation for the successful construction of the building that bears his name.

During the 1955–1956 academic year, nursing student Ellen Tully served as ASUSF secretary, the first female ASUSF officer in the history of the institution. Pictured here with Ellen Tully is Jeremy Harrison, class of 1957.

In 1964, Frances Anne Dolan was selected as USF's first dean of women. She retired as vice president for student development 23 years later. For almost a quarter of a century, she brought a superb leadership style to the university's student affairs administration. In recognition of her many achievements, the university established a scholarship fund in her name to assist student athletes complete their degrees.

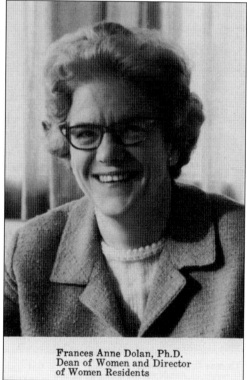

Frances Anne Dolan, Ph.D.
Dean of Women and Director of Women Residents

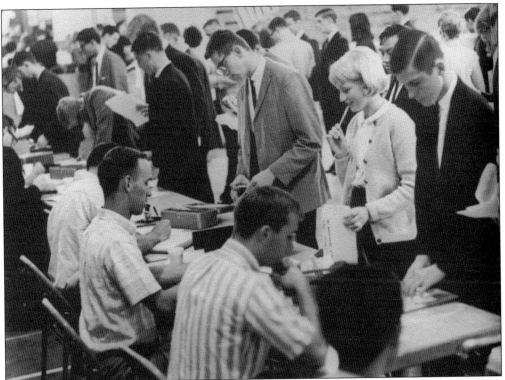
In 1964, men and women registered together for classes in the regular day division for the first time in the history of the University of San Francisco.

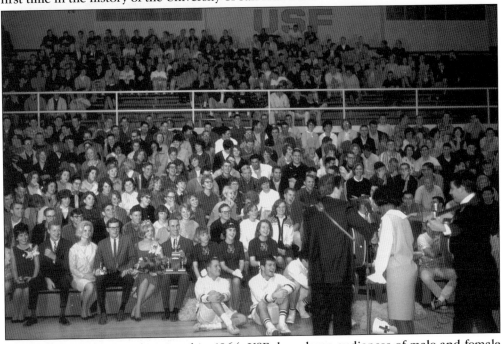
As a result of going coeducational in 1964, USF drew large audiences of male and female students to musical and other special events.

Marisa Dryden, USF philosophy major and member of the SWAP executive committee, tutors students in a Western Addition neighborhood study hall in 1964.

Pedro Arrupe, SJ, superior general of the Society of Jesus, visited San Francisco in April 1966, where he was honored at a USF alumni banquet hosted by Edmund G. Brown, governor of California, and John Shelley, mayor of San Francisco and a graduate of the USF School of Law.

Charles Dullea, SJ, (left) president of USF from 1963 to 1969, pictured here with Jack Curtis, sociology professor and a student coordinator of the United Crusade on campus, was strongly supportive of the efforts by faculty, staff, and students to provide a wide range of community support services.

Arthur Furst (standing), founder of USF's Institute for Chemical Biology in 1961, achieved international acclaim and obtained numerous federal grants and private foundation gifts for his pioneering research and publications on the environmental causes of cancer. He is credited with establishing the field of toxicology.

Robert Seiwald, professor of chemistry from 1957 to 1989, made such significant discoveries about antigens (bacteria and viruses) that he was inducted into the national Inventors Hall of Fame.

USF physics professor Eugene Benton (right) worked directly with many USF students (including Jerry Whalen, left) on his physics experiments, including the detection of radiation in outer space and on earth. Dr. Benton, who taught at USF from 1969 to 2012, twice received the university's Distinguished Research Award. He became internationally known for his pioneering experiments on the detection of radiation in outer space and from earth-bound particle accelerators. Beginning in the 1970s, his experimental devices were on every manned and unmanned NASA mission, including on the Apollo series spacecraft. From 1986 to 2001, he also led joint American-Russian experiments on the effects of long-term space radiation on humans aboard the Russian space station *Mir*.

In 1966, USF began to offer a bachelor's degree in computer science; four years later, 10 USF students graduated with a degree in computer science. By 1970, USF had also installed a state-of-the-art mainframe computer—the RCA Spectra 70. It was one of the first computers at a West Coast university, required special air conditioning, filled several rooms in Harney Science Center, and had all of one megabyte of internal memory. Students used the computer for various projects, including assisting the San Francisco School Board to reassign public school students to reduce school segregation.

Charles Dullea, SJ, 22nd president of the University of San Francisco, helped shape a new era for the university, which included the admission of women to the undergraduate day division for the first time, the construction of five new buildings on campus, the development of several new academic and community outreach programs, and a dramatic increase in student enrollment.

An aerial view shows the University of San Francisco in 2014. From 1970 to 2014, USF witnessed extraordinary change: student enrollment grew from less than 6,800 to more than 10,700 students; the number of full-time faculty members increased from 230 to 459; the institution significantly increased in acreage and number of buildings; and the university developed a multitude of new, on-campus, regional, and international programs.

Six

THE 1970S TO THE 2000S

During the early 1970s, the United States witnessed a continuation of many of the problems from the 1960s while several new challenges arose for institutions of higher education. The Vietnam War continued until 1973, and in its wake, the nation faced a huge war-related national debt, recession, and runaway inflation. Compounding the economic problems that affected all segments of the nation, institutions of higher education also faced a decline in the number of traditional undergraduate students as the last cohort of children born immediately after World War II moved through the nation's schools. Colleges and universities were caught in a cycle of rising prices, national recession, and declining enrollments. The University of San Francisco was especially hard hit by these external forces.

Albert Jonsen, SJ, who served as president from 1969 to 1972, and William McInnes, SJ, who was president from 1972 to 1976, sought to grapple with the mounting financial and enrollment crisis at USF. In the face of significant budget deficits, Father McInnes instituted major budget cuts, wage freezes, and a large tuition increase, and he began the process of cutting staff and faculty. As was the case at many other colleges and universities that were facing similar economic problems and potential layoffs, the faculty at USF decided to unionize, and the USF Faculty Association was born in 1975. Father McInnes resigned in 1976 and was replaced the next year by John Lo Schiavo, SJ, who began a 14-year tenure as president of USF. During his administration, enrollment began to increase, the budget was balanced, and a major capital campaign was successfully completed. USF acquired the Lone Mountain campus, the Koret Health and Recreation Center was built, and the College of Professional Studies and the Center for the Pacific Rim were established along with several other programs.

When Father Lo Schiavo retired from the presidency in 1991 to become its chancellor, the institution was on a solid financial base, and his successor, John Schlegel, SJ, was able to capitalize on the university's fiscal and human strengths to move the institution forward in several areas. From 1991 to 2000, USF saw a significant increase in its enrollment and the diversity of its students, and the institution benefited from the largest and most successful fundraising campaign in the university's history. During Father Schlegel's tenure, several

buildings were renovated; the Gleeson Library was transformed by the addition of the Geschke Learning Resource Center; the Dorraine Zief Law Library was built; the Jesuits moved to a new home on Lone Mountain, Loyola House; and renovations were completed on a new building for the School of Education purchased from the Sisters of the Presentation, a religious order with which USF also arranged a lease-purchase option on another building destined to be the new home for the College of Professional Studies.

A major housing project for faculty and staff, Loyola Village, was initiated on the north side of Lone Mountain, though it ultimately became primarily a student residence. In 2000, Father Schlegel left USF to become president of Creighton University, and Stephen A. Privett, SJ, provost and academic vice president of Santa Clara University, was chosen as the 27th president of the university.

During the first year of his presidency, Father Privett and his leadership team, with insights from trustees, alumni, faculty, and staff, crafted a new vision, mission, and values statement. The vision, to make USF a "premier Jesuit Catholic, urban University with a global perspective" that "educates minds and hearts to change the world" has found expression in a multitude of values-based programs on campus and around the world. At USF, the activities of the new Leo T. McCarthy Center for Public Service and the Common Good exemplify this emphasis on social justice programming, as do a multitude of international programs sponsored by the university and its schools and colleges. During Father Privett's administration, the institution also witnessed continuing growth in student enrollment and student diversity, the establishment of the Koret Law Center, the creation of the Ralph and Joan Lane Center for Catholic Studies and Social Thought, the completion of facilities for a new fine arts program, a new budgeting and planning process, the development of a master plan outlining major renovations throughout the campus over the next decade, and the initiation of a core network infrastructure project to dramatically enhance student learning and administrative services through technology.

In August 2014, the John Lo Schiavo, SJ, Center for Science and Innovation was completed. The Lo Schiavo Science Center represented the crowning building achievement of Father Privett's administration. Father Privett tirelessly raised money for the new building, as did Father Lo Schiavo, David Macmillan, vice president for university advancement, Sally Danton, associate vice president from university advancement, physics professor Brandon Brown, and many others.

On November 1, 2014, Paul J. Fitzgerald, SJ, was inaugurated as USF's 28th president. Father Fitzgerald had worked in higher education for more than 20 years, and before becoming USF's president, he served as the senior vice president for academic affairs at Fairfield University in Connecticut. He came to office at a propitious time in the institution's history.

SAN FRANCISCO FOGHORN

Vol. 64, No. 25 May 8, 1970 751-3118

Protesting Ohio killings
STRIKE IS ON

By Ron Fontana
Foghorn Managing Editor

A general strike in support of the ASUSF demands, in sympathy for the students murdered at Kent State University, and in opposition to the United States' involvement in Cambodia has been called for today in action by the new student senate Tuesday night.

The senators, who campaigned for office on the idea of organization and action, called the strike with the understanding that further action will be taken if the demands of ASUSF are pus be exposed. In no way shall this investigation be understood as a disciplinary action.

2. We demand that the University agree to hire minority faculty, administrative and staff members for Spring Semester, 1971. That the departments and deans give the student body a progress report on the attempts to hire minority faculty by May 14.

3. We demand an immediate implementation of an Ethnic Studies Department along the lines of the Ethnic Studies Committee already in existence. Further

The senate first passed a motion for a strike in protest of the Kent State University murders, the illegal invasion of Cambodia, and the disciplinary hearing of the students involved in the incident of March 6.

Senators Tony Geraldi and Bill Topf moved to change "murder" to "killing"; the motion failed.

Lee Medieros and Simon Mayeski moved to change "Friday" to "for an indefinite time", but they withdrew the motion.

Alice Kerrigan and J. L. Broderick moved to change "recommend a strike" to

Shut it down

"It's better for us to fight for something we want and lose than fight for something we don't want and win."
—Eugene Debs

At the beginning of its meeting Tuesday night, the Student Senate voted (14-1) to call a general strike of the University on Friday to protest the invasion of Cambodia and the murder of the four Kent State Students, and to demand the end of any "trial" or disciplinary action stemming from the incidents of March 6 on this campus.

The Senate then proceeded to consider various additions to this simple and effective resolution. After three hours of confused debate, it arrived at the statement which has since been published.

The front page of the *Foghorn* on May 8, 1970, announced the response of the USF Student Senate to the extension of the Vietnam War into Cambodia and the killing of four students by National Guardsmen at Kent State University in Ohio.

Many colleges and universities across the nation were shut down by student strikes following the killing of four students by National Guardsmen at Kent State University during a Vietnam War protest on May 4, 1970. USF president Albert Jonsen, SJ, agreed to suspend classes on May 8 so that students, staff, and faculty could attend a series of on-campus teach-ins addressing the Vietnam War.

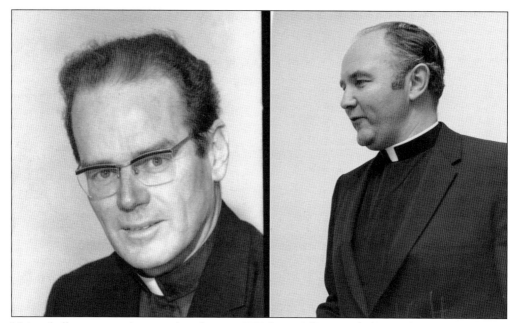

Major challenges were in great abundance at USF from 1969 to 1976, during the administrations of Albert Jonsen, SJ, (left) the 23rd president of USF, and William McInnes, SJ, the 24th president of the institution.

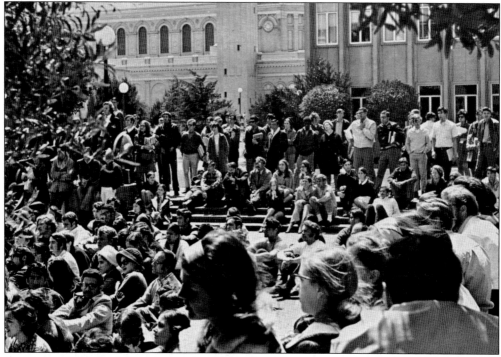

On May 7, 1970, the ASUSF Senate moved outdoors, where a crowd of students gathered in Harney Plaza to hear speakers denounce the United States' incursion into Cambodia during the Vietnam War and express sympathy for four students killed by National Guardsmen at Kent State University three days earlier.

This 1971 photograph shows the Harney Science Center (the center building with the large plaza, also named Harney, directly in front of it). To the right of Harney Plaza is University Center, completed in 1965. Classrooms, science laboratories, and the administrative offices of the College of Arts and Sciences were located in the Harney Science Center, completed in 1966. The building commemorated the generosity of the late Pauline and Charles Harney to USF and their lifelong friendship with its Jesuit community. Charles Harney was a regent of USF and responsible for many campus improvements.

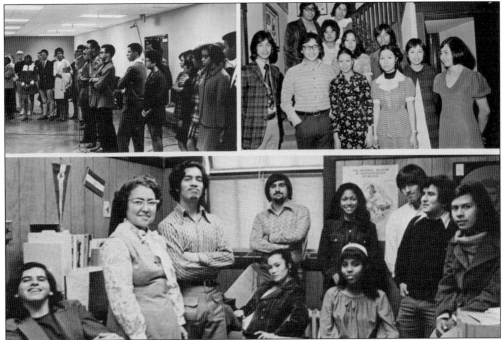

During the 1970s, USF saw an increase in the number of ethnic minority students on campus, a fact reflected in the growth of student organizations such as the Black Student Union (top left), the Philippine Club (top right), and La Raza (bottom).

The vote by the USF faculty to unionize was proclaimed in a Foghorn headline on September 26, 1975.

Michael Lehmann (left) was the founding president of the USF Faculty Association in 1975.

In the 1980s, Harney Plaza with its fountain in front of the Harney Science Center was a major gathering point for students (such as the two USF students nearest to the fountain, Mary Beth Bonnacci and John Sefranek). The fountain also served as an outdoor venue for speeches, concerts, rallies, and other university events.

In 1976, Alfred and Hanna Fromm translated their lifelong interest in contributing to the community and their ideas about lifelong learning into an educational program for retirees at the University of San Francisco.

Students from the Fromm Institute for Lifelong Learning walk near Harney Plaza in this photograph from 1991. The institute's student population grew from 76 in 1976 to 1,300 in 2014. Currently, the median age of Fromm Institute students is 72.

Phil Smith led the USF men's basketball team in scoring from 1971 to 1974, was an All-American in 1974, and led the Golden State Warriors to their only NBA championship in 1975.

Guests at the opening of the Koret Health and Recreation Center on September 17, 1989, were greeted by a statue of Jesse Owens, the great African American athlete who won four gold medals at the 1936 Olympic Games, held in Germany.

Approximately 2,300 people attended the dedication festivities for the Koret Health and Recreation Center on September 17, 1989. San Francisco mayor Art Agnos (pictured here walking with Father Lo Schiavo), state senator Milton Marks, Susan Koret, and Melvin Swig were among the dignitaries in attendance.

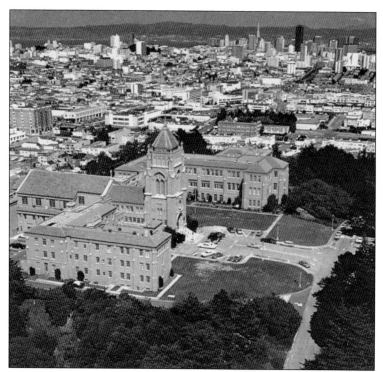

The USF School of Continuing Education was the immediate antecedent of the College of Professional Studies, shown in this 1979 photograph of the west wing of the Lone Mountain campus. In 2009, the College of Professional Studies merged with the School of Business and Management, which was renamed the School of Management.

In 1983, Michael O'Neill, former dean of the School of Education and founder of the Institute for Catholic Educational Leadership, began the Institute for Nonprofit Organization Management in the College of Professional Studies. The institute offered one of the nation's first master's degrees in nonprofit administration, developed certificate programs, organized major conferences with world-class speakers, conducted pioneering research in the field, and became the most successful fundraising institute in the history of USF.

During the more than 14-year presidency of John Lo Schiavo, SJ, USF was significantly transformed: financial stability was restored, enrollment grew, Lone Mountain was acquired, the Koret Health and Recreation Center was built, and a multitude of new academic programs were successfully launched.

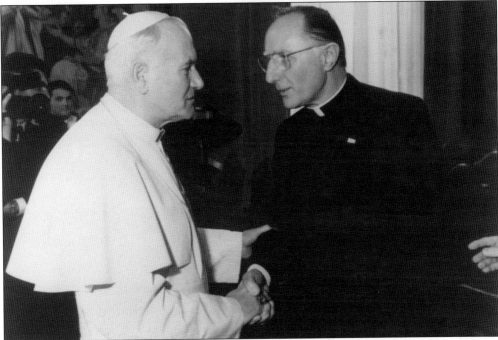

"We look forward to welcoming you to San Francisco in 1987," said USF president John Lo Schiavo, SJ, to Pope John Paul II when Father Lo Schiavo and 80 other presidents of Jesuit institutions from throughout the world met with the pope in Rome in 1985.

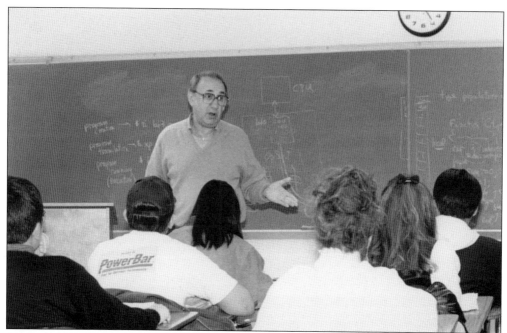

Beginning in 1974, Michael Kudlick taught in the computer science department for 23 years, chaired the department, won the Distinguished Teaching Award, and had a state-of-the-art computer classroom named in his honor, a result of a major gift by one of his former students, Alfred Chuang, who was inspired by Professor Kudlick's teaching and mentoring.

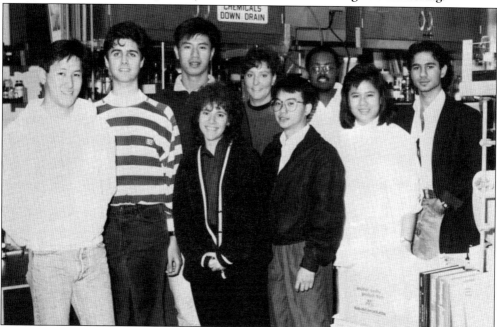

The growth in student diversity during the 1980s at USF is reflected in the 1989–1990 Chemical Society in the College of Arts and Sciences. From left to right are (first row) Makoto Takahashi, Joe Leonetti, Regina Matamoros, Luong Truong, and Natalie Limson; (second row) Ronald Limsin, Stephanie Grzybicki, Samson Berhane, and Ramsey Deeik.

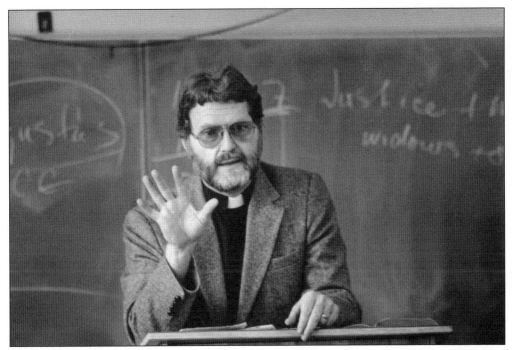

John Elliott, a Lutheran minister, taught theology and religious studies at USF for 34 years. He received the Distinguished Teaching Award and twice won the Distinguished Research Award.

Beginning in 1969, Elisabeth Gleason taught history at USF for 28 years, published numerous books and articles, served as president of the American Society for Reformation Research, and was the first recipient of USF's Sarlo Prize, recognizing teaching excellence that exemplifies the ethical principles underlying the university's vision, mission, and values.

Melvin Swig, businessman, developer, and philanthropist, funded the Swig Judaic Studies Program at USF in 1977. Swig joined the USF Board of Trustees in 1983 and became its chairman in 1985.

Barbara Bundy, the first executive director of USF's Center for the Pacific Rim, meets with Edward Malatesta, SJ, cofounder of USF's Ricci Institute for Chinese Western Cultural History.

Valerie Gillon celebrates after the Lady Dons basketball team won its second straight West Coast Conference Tournament in 1996. She was the WCC Tournament MVP in 1995 and 1996 and the WCC Scholar-Athlete of the Year in 1996 and is a member of the USF Hall of Fame.

Kari McCallum was an all-conference MVP in women's cross country and tennis and also played on the basketball and soccer teams. In 1992, she graduated from USF with a nearly straight-A average and received the Anne Dolan Award as the outstanding female student athlete of the year. She was inducted into the USF Athletic Hall of Fame in 2001.

Senior outside hitter Brittanie Budinger helped power the USF volleyball team to its best season ever and an NCAA tournament berth in the spring of 2004. She was the first volleyball player, the third woman in the university's history, and the ninth individual at USF to have her jersey retired.

Gerardo Marín (second from the right) is currently senior vice provost for academic affairs and professor of psychology and Latin American studies at USF, having started his career at USF in 1982 as an assistant professor of psychology and rising through the College of Arts and Sciences to become its senior associate dean. He has written more than 150 books and articles on topics related to Hispanics, including cultural norms, risk behaviors, and culturally appropriate methodology. Marín obtained various federal and private grants and was instrumental in the development of numerous new academic programs, including the Center for Latino Studies in the Americas, the Martín-Baró Scholars Program, and many international programs. In 2005, he received an honorary doctorate from Peter Pazmany Catholic University in Budapest, Hungary. In 2013, Dr. Marín was selected by the Fusionarte Association as one of the 100 Colombians of significance worldwide for his many contributions to higher education and his academic achievements. In this 1998 photograph, Marín is pictured with four other arts and sciences faculty members who served on the governing board of the Center for Latino Studies in the Americas, including, from left to right, the late Esther Madriz (sociology), Eduardo Mendieta (philosophy), Michael Stanfield (history), and Lois Lorentzen (theology).

On April 3, 2004, more than 350 students, community volunteers, and faculty members from the computer science department at the University of San Francisco organized the first flash mob supercomputer event in history, linking 669 individual computers to a network capable of performing 180 billion mathematical operations per second.

In the spring of 2004, a group of law students and USF law professor Constance de la Vega traveled to the UN's Commission on Human Rights in Geneva, Switzerland, to present oral and written statements on several international human rights issues, including the trafficking of women and children, domestic violence, arbitrary detention, the rights of migrant workers, and the juvenile death penalty. Pictured here from left to right are (first row) USF law students Sarah Canepa and Jen Noegele; (second row) Boalt Hall law student Lynsay Skiba, USF law students Jacqueline Brown Scott, Jean Covington, and Nikki Beluschko, and Professor de la Vega.

Ming Chin earned a bachelor's degree in political science from USF in 1964 and a law degree from USF in 1967. In 1996, he was appointed associate justice of the California Supreme Court. He has served on the USF Board of Trustees, was president of the alumni association, and was honored as Alumnus of the Year by both the university and the law school, where he has taught as an adjunct professor.

Malloy Hall, the home for the School of Management, was dedicated in September 2004. It is named in honor of Thomas E. Malloy, chairman of the USF Board of Trustees, whose major gift made the new building a reality.

The School of Education Building, formerly Presentation High School, was acquired by USF in 1991. It houses the School of Education faculty and administrative offices, classrooms, the Center for Instruction and Technology (CIT), and a theater that seats 500 people.

Louis Giraudo, chairman and chief executive officer of Pacific Coast Bakery, was appointed chairman of the USF Board of Trustees in 1992. During the board meeting of September 15, 1992, USF president John Schlegel, SJ, (right) gave him his gavel—made of sourdough.

In 1997, the Geschke Learning Resource Center was added to the Gleeson Library. Pictured here cutting the dedication ribbon are, from left to right, Louis Giraudo, chairman of the USF Board of Trustees; Nancy Geschke; USF president John Schlegel, SJ; and Charles Geschke, cofounder of Adobe Systems and future chairman of the USF Board of Trustees.

John W. Clark, SJ, served as provost and academic vice president of USF from 1988 to 1997, a period of significant growth in student enrollment, new program development, and enhanced relations between the USF Faculty Association and the administration.

During their 2004 spring break, USF students Marcie Rodriguez (left) and Celestine Johnson worked to enhance the lives of families in the Guatemalan village of San Lucas Toliman. For decades, the University of San Francisco's students, faculty, and staff have been engaged with local, national, and international communities in providing services to those in need. In 2006, USF received the Carnegie Foundation's Community Engagement classification for curriculum engagement, outreach, and partnerships. USF was among only 62 schools that received this honor during the first year it was granted. This Carnegie Foundation classification was renewed in 2015 for 10 years. In 2013, for the seventh straight year, and for the third time "with distinction," USF was named to the President's Higher Education Community Service Honor Roll by the Corporation for National and Community Service. This honor highlights USF students' exemplary service on issues ranging from poverty and homelessness to environmental justice. Honorees are chosen on the basis of the scope and impact of service projects, percentage of students participating in service activities, and the extent to which the school offers academic service-learning courses. At USF, service learning is required of all undergraduate students.

In January 2004, the University of San Francisco School of Law dedicated its new Koret Law Center, named for the project's principal donor, the Koret Foundation. The Koret Law Center includes Kendrick Hall, which opened in 1962, and the Dorraine Zief Law Library, which opened in 2000. (Courtesy of Archer Design, Inc.)

Stephen A. Privett, SJ, served as the University of San Francisco's 27th president, from 2000 to 2014. His administration witnessed the development and implementation of a new vision, mission, and values statement for the university, continuing growth of a diverse student body, major campus improvements, renovations, and technology upgrades, several new academic programs and institutes, and the successful launching of the largest fundraising campaign in the history of USF.

The University of San Francisco announced the establishment of the Leo T. McCarthy Center for Public Service and the Common Good at a press conference on November 30, 2001. The McCarthy Center "is about creating a better society for all—through teaching, faculty scholarship, publications, and forums," USF president Stephen A. Privett, SJ, said at the press conference. Pictured from left to right are USF student Liz Holstein (daughter of donors Robert and Loretta Holstein), Father Privett, former lieutenant governor of California Leo T. McCarthy (a USF graduate and donor to the center), donors Joan and Ralph Lane (USF sociology professor emeritus), and former San Francisco mayor Art Agnos.

In September 2003, the Dalai Lama made a historic visit to the University of San Francisco. He spent several days on campus, where he met with students, faculty, and staff; gave two public presentations; and was awarded an honorary doctorate. He was escorted around campus by USF president Stephen A. Privett, SJ, (left) and John R. Treacy, SJ, (right) rector of the Jesuit community.

Bethany Goodrich (left), class of 2011, Austin Gajewski (center), class of 2013, and Deneb Karentz, USF professor of biology and environmental science, collect phytoplankton samples from a hole they cut in the ice covering the Antarctic Ocean. Professor Karentz has been conducting research, often with her students, and teaching in Antarctica for more than 20 years. Deneb Karentz has a lake named after her in Antarctica due to her contributions to understanding the world's southernmost continent.

Jennifer Turpin, the first female provost in the history of the University of San Francisco (top left), hosted the Women in Science Symposium at USF on September 19, 2013, in conjunction with the opening of the John Lo Schiavo, SJ, Center for Science and Innovation. Next to Provost Turpin is Margaret Tempero, director of the UCSF Pancreas Center and a USF trustee. Seated from left to right are Gini Deshpande, founder and chief executive officer of NuMedii; Juliet Spencer, professor of biology at USF; Ellen Daniell, author of *Every Other Thursday: Stories and Strategies from Successful Women Scientists*; and Nola Masterson, managing director of Science Futures.

Located in the center of the USF campus, the John Lo Schiavo, SJ, Center for Science and Innovation (right) was completed in the summer of 2013. It has 17 teaching labs and classrooms and contains state-of-the-art scientific equipment for use by undergraduate and graduate students. On a pedestal at the end of a grass-covered portion of the science building (left of center) stands an exact replica of an armillary sphere, a six-foot-diameter instrument for measuring time and tracking celestial bodies. The original instrument was constructed by a 17th-century Jesuit, Fr. Ferdinand Verbiest, and placed in the imperial observatory in Beijing, China, where it still resides.

The USF Council of Deans in the fall of 2014 included, from left to right, Judith Karshmer, dean of the School of Nursing and Health Professions; Kevin Kumashiro, dean of the School of Education; John Trasviña, dean of the School of Law; Jennifer Turpin, provost; Marcelo Camperi, dean of the College of Arts and Sciences; Elizabeth Davis, dean of the School of Management; and Tyrone Cannon, dean of the Gleeson Library and Geschke Learning Resource Center. (Courtesy of Paul Morrill, University of San Francisco.)

On April 8, 2014, the University of San Francisco Board of Trustees voted unanimously to elect Paul J. Fitzgerald, SJ, as the 28th president of the university. Father Fitzgerald has worked in higher education for more than 20 years, and before becoming USF's president, he served as the senior vice president for academic affairs at Fairfield University in Connecticut, where he oversaw the recruitment and retention of faculty, developed curriculum, and worked with the deans to direct academic programs. Previously, he worked at Santa Clara University as associate dean and senior associate dean for the College of Arts and Sciences. He serves on the board of trustees at Loyola University Chicago, Illinois, and has previously served on the board of trustees of Loyola Marymount University in Los Angeles. Father Fitzgerald has lived, taught, and studied overseas, helping him to develop a global vision. He is fluent in German and French and is conversational in Spanish. He earned a DEA (*diplôme des études approfondies*) and a *docteur ès lettres* (PhD) in the sociology of religion at the University of Paris (la Sorbonne), and received an STD (pontifical doctorate) in ecclesiology from the Institut Catholique de Paris. He taught as a visiting lecturer in China during the summer of 1992 and in Kenya in 2004.

More than 1,000 people attended the installation ceremony of Paul J. Fitzgerald, SJ, as the 28th president of the University of San Francisco on November 1, 2014, following three days of inaugural celebrations to honor the achievements of USF students, faculty, staff, and alumni. Father Fitzgerald is pictured here during the installation ceremony in St. Ignatius Church being congratulated by Janet Napolitano, president of the University of California. Seated from left to right in the front row are Congresswoman Nancy Pelosi, House Democratic leader; Gavin Newsom, lieutenant governor of California; Sr. Geneviève Médevielle, past rector, Institute Catholique de Paris; and Willie Brown, former mayor of San Francisco. Behind the first row are the USF trustees, emeriti trustees, and members of the leadership team. Student body officers and other members of the USF community are also on the platform. (Courtesy of Danielle Maingot, San Francisco *Foghorn*.)

DISCOVER THOUSANDS OF LOCAL HISTORY BOOKS FEATURING MILLIONS OF VINTAGE IMAGES

Arcadia Publishing, the leading local history publisher in the United States, is committed to making history accessible and meaningful through publishing books that celebrate and preserve the heritage of America's people and places.

Find more books like this at
www.arcadiapublishing.com

Search for your hometown history, your old stomping grounds, and even your favorite sports team.

Consistent with our mission to preserve history on a local level, this book was printed in South Carolina on American-made paper and manufactured entirely in the United States. Products carrying the accredited Forest Stewardship Council (FSC) label are printed on 100 percent FSC-certified paper.